POSTCARD HISTORY SERIES

Lewes to Laurel

IN VINTAGE POSTCARDS

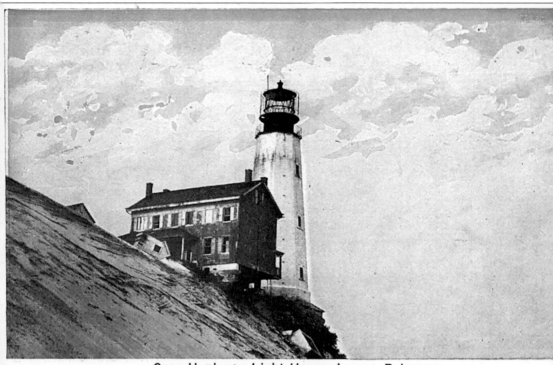

Cape Henlopen Light House, Lewes, Delaware

THE CAPE HENLOPEN LIGHTHOUSE. The lighthouse was built in 1765, but the tower was not completed until 1767. Although damaged during the Revolution, it was restored and re-lighted in 1784. The lighthouse was built of stone and was octagonal in shape. The light remained in service until October 1, 1924. It stood until April 13, 1926, when it collapsed into the sea. Recently a moving contractor from Sharptown, Maryland, successfully moved a similarly threatened one, but no such service was available in 1926. The stones from the crumbled Cape Henlopen Lighthouse were hauled away by members of the public as souvenirs or for use in homes and gardens. In this picture the erosion that has already caused abandonment of the lighthouse keeper's house and endangered the foundation of the lighthouse is visible.

POSTCARD HISTORY SERIES

Lewes to Laurel

IN VINTAGE POSTCARDS

John Jacob, Edward Fowler, and Neal Boyle

ARCADIA
PUBLISHING

Copyright ©2003 by John Jacob, Edward Fowler, and Neal Boyle.
ISBN 978-0-7385-1571-7

Published by Arcadia Publishing
Charleston SC, Chicago IL, Portsmouth NH, San Francisco CA

Printed in the United States of America

Library of Congress Catalog Card Number: 2003109384

For all general information contact Arcadia Publishing at:
Telephone 843-853-2070
Fax 843-853-0044
E-mail sales@arcadiapublishing.com
For customer service and orders:
Toll-Free 1-888-313-2665

Visit us on the Internet at www.arcadiapublishing.com

CONTENTS

PREFACE

One of the authors lives in Lewes, one in Laurel, and one in Seaford. All three have been enthusiastic postcard collectors for years and Mr. Boyle is also a dealer. They have collaborated in this collection of views.

John Jacob volunteered for the job of selecting the cards to be shown. Because he is a retiree, he could devote many hours to the time-consuming research after the selections were made and to ferreting out the "old folks" in these towns who could remember times past. In writing the captions he has endeavored to highlight the things that make each scene unique. If there is an error, he is to blame.

One factor needs to be pointed out about postcard collections—one view may have been photographed dozens of times from different angles and have different legends written on the top or bottom of the card. Therein lays the fascination of collecting. A card may be creased or faded, but if the scene is rare, it must be used. Some cards have been selected because the forces of nature, hurricanes, floods, fire, and the like, have changed the scene dramatically. The story is in the caption.

Postcards are the bygone "show and tell" of history.

Edward Fowler, Neal Boyle, John Jacob

INTRODUCTION

Route 9 extends in a southwesterly direction from the Delaware Bay at Lewes through Georgetown, the county seat of Sussex County, to Laurel. While connected by the highway, these three communities are completely different.

Lewes dates back to the 1600s. Henry Hudson visited the site on his quest for a Northwest Passage to Asia. Then the Dutch sent a colonizing group of people who were all killed by Native Americans. The Swedes were next in line, and the English were third. Lewes lives by its history and has a very active historical society. During the War of 1812 the British bombarded it; the American cannons are still in place. A lighthouse was built at Cape Henlopen, which eventually collapsed into the sea. The town has a hospital that enjoys an excellent reputation and a summer retirement colony that astounds. A ferry runs from Lewes to Cape May, New Jersey, which brings additional visitors to Route 9.

Georgetown is much different. Founded in 1791, it is the county seat of Sussex County. Georgetown is centrally located and provides government for the people of Sussex. As the judicial center of the county, most lawyers find their homes there. It is also the center of the poultry industry and the home of a sizeable colony of Spanish-speaking immigrants.

Laurel was founded in 1802 on the site of a former Indian reservation. It is the home of a prosperous farming and poultry industry, a lumber business, a manufacturer of baskets, boxes, and crates, a fertilizer company, and a canning industry. Laurel has navigable water in Broad Creek. It was considered at one time to be one of the wealthiest towns in the state.

While one or more of these towns may have produced enough postcards to form the basis of a book, the three of them together have produced enough to make an interesting and rewarding volume.

ACKNOWLEDGMENTS

Our first and most fervid acknowledgement is to Lynne Rentschler, John Jacob's former secretary, who has typed all of our commentary and captions for this book including those that had to be retyped to eliminate errors or expanded to make room for additional facts, and all without charge.

To our wives for listening to our discussions, making suggestions, and having patience for time devoted to postcards.

To Hazel D. Brittingham—without sharing her fountain of information about Lewes and its people, the chapters on Lewes could never have been written.

To Rosalie Wells, secretary of the Georgetown Historical Society, for her helpfulness and identification of cards, and also to Ronnie Dodd, the Town Crier, whose advice about Georgetown was so valuable.

To Caleb Fowler, father of one of the authors, who cheerfully helped with his knowledge of Laurel and its environs, to Kendal Jones who shared his vast knowledge of the community, and to Irene Allen who made herself available at all hours to answer questions about Laurel.

To Lieutenant Richardson of the Laurel Police Department who came to John Jacob's assistance with car trouble.

And, last but not least, to Retta Mills, another former secretary of John Jacob's, who handled all of our correspondence.

One

MARITIME LEWES

Lewes has a long and fascinating history—the site of a Dutch trading post in 1620 and a Swedish settlement in 1632; granted to Maryland in 1634, then bought from the Duke of York by William Penn; made the county seat by Penn in 1658 and remained so until 1791; besieged by the British in 1813; incorporated as a town in 1818; the site of breakwaters and aids to navigation; the largest seafood landing port in America in 1953, yet in a few years was out of contention when the menhaden industry collapsed; a beach resort; at the mouth of a canal on an inland waterway; and, above all, a great place to call home.

For the purposes of this book we have divided Lewes's story into three chapters. The first concerns those aspects of its life connected with the sea; the other two, those aspects that are more properly a part of its land development and are only indirectly connected with its location on Delaware Bay.

Since its founding, Lewes has relied on its position at the mouth of Delaware Bay. As a Dutch trading post, it depended on its ready access to the sea; as an American seaport, its location within range of cannon fire from British ships made it vulnerable; for the pilots who conned the ships going up river, it was home; in later times the processing plants for menhaden were located here.

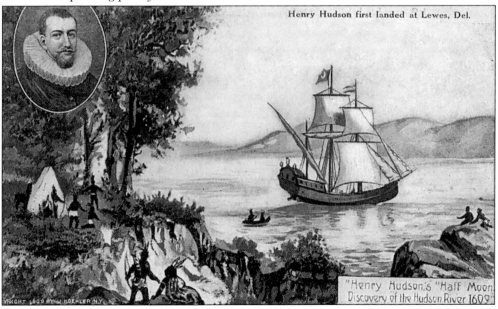

Henry Hudson first landed at Lewes, Del.

"Henry Hudson's "Half Moon" Discovery of the Hudson River 1609"

HENRY HUDSON FIRST LANDED AT LEWES, DELAWARE. Hudson discovered the Delaware River, which he called the South River. He was seeking a shorter route to China, but when he scraped on a sand bar and felt the current of a river, he realized he had not found a Northwest Passage. He sailed on and discovered the river that now bears his name. The English renamed the river after Lord De La Warr to bolster their claims to a large chunk of North America, so Hudson's visit remains only a curiosity.

9

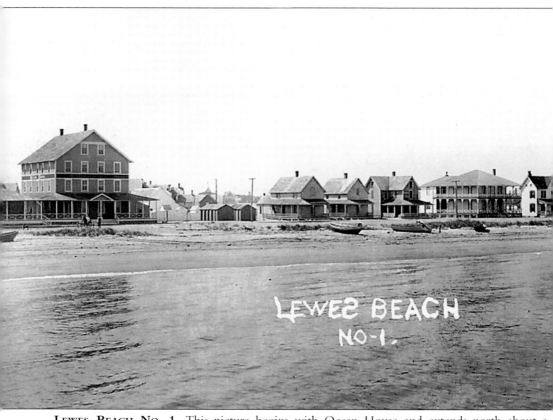

LEWES BEACH NO. 1. This picture begins with Ocean House and extends north about a block, showing how the beach looked *c.* 1905. The porch on Ocean House has been extended. This picture shows how little protection against wind and wave was required of structures built north of Cape Henlopen. Note also how many boats were drawn up on the sands waiting to be launched. The commercial area of Lewes was grouped around Savannah Avenue.

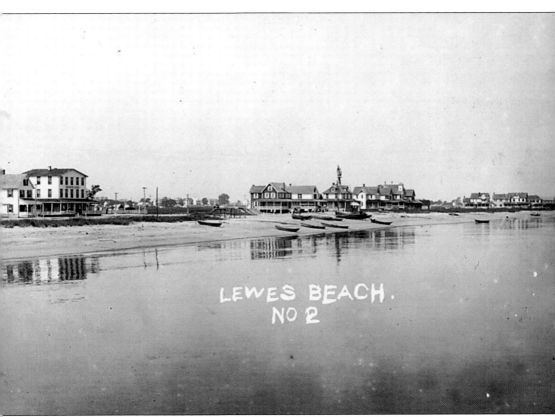

LEWES BEACH NO. 2. This begins at Breakwater House and runs north. About ten boats are beached on the sands waiting for high tide to launch them. Electric poles can be seen past Breakwater House, but the lack of them further north may indicate the lack of electricity. The object sticking up in the middle of the block past Breakwater House is a windmill, showing a lack of a water system.

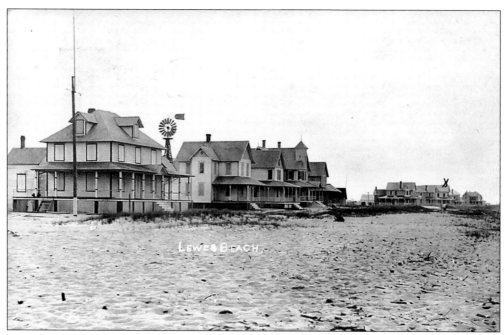

LEWES BEACH. The windmill behind the second house on this picture indicates that no public water system is available in this group of houses. What appears to be an electric pole can be seen behind the next group of houses. This card is postmarked July 7, 1908.

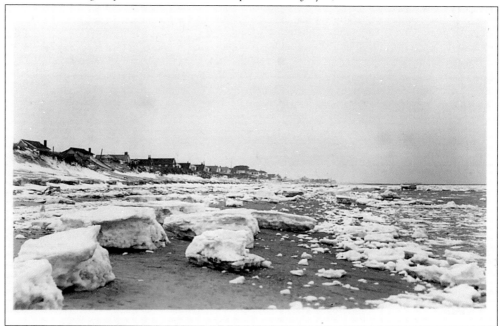

ICE FLOES ON THE BEACH. The ice floes pictured here have diminished in size and weight by having reached the sea. Imagine their size and weight when they broke loose in the upper reaches of the river and what damage they could have done to the wooden hull of a sailing ship. Ice barriers are built to protect ships above the west end of the "Harbor of Refuge" and to protect shipping on the west end of the original breakwater.

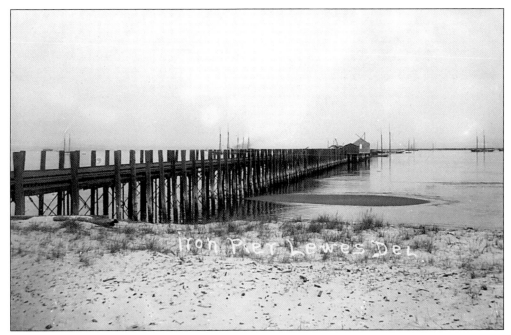

THE IRON PIER. This pier was constructed in 1871 by the federal government at a cost of more than $500,000 and was about 2,000 feet long. In 1884 railroad tracks were added to meet steamships. It also served the menhaden processing plants. The pier was torn down in 1990 by the developers of Cape Shores.

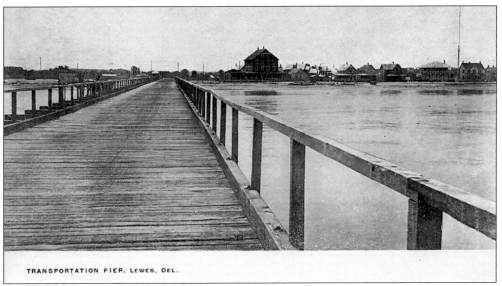

TRANSPORTATION PIER, LEWES, DEL.

TRANSPORTATION PIER. Built in 1898 by the Queen Anne Railroad, the Transportation Pier met the ferry from Cape May, the *Queen Caroline*. It was 1,202 feet long. The pier long outlasted the railroad for whose use it was built. It was used for water and fuel for any ships that called and for local fishermen. The first section was wrecked on February 21, 1936, by ice, an extreme high tide, and a strong wind. The second section of about 800 feet went and the last 200 feet were destroyed on January 24, 1940, by ice and blizzard.

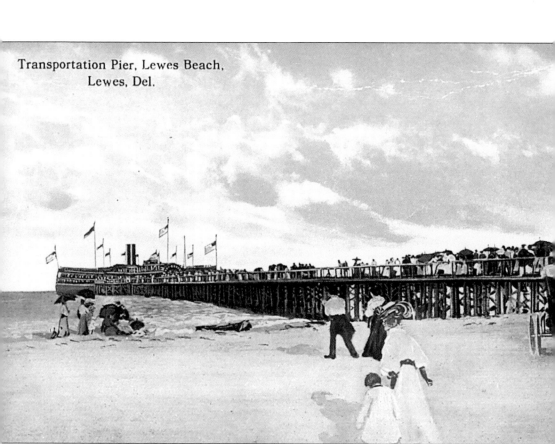

Transportation Pier, Lewes Beach,
Lewes, Del.

TRANSPORTATION PIER. This card was published at a time when the steamers from Philadelphia made regular trips to Lewes. This was for a short time around 1900 when the transportation pier was at its longest.

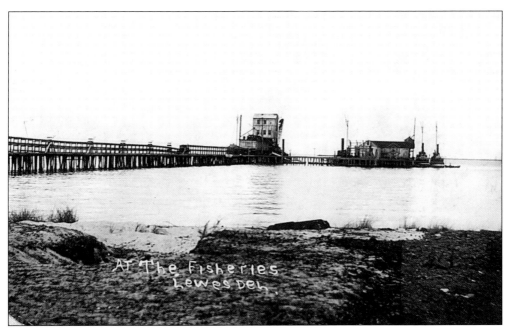

THE FISHERIES. The menhaden is a small, oily fish about a foot long and weighing about a pound. Its breeding grounds were in the area of the Atlantic between New York and Virginia and close to the American coast. The menhaden is not used for human consumption, however, it was used for fertilizer and the processing plants were located in Lewes. The companies hired aviators to spot the schools of fish and the direction in which each was moving. Boats were then dispatched to intercept them. In 1953 Lewes was the largest seafood landing place in the nation with 390 million pounds of fish landed, of which 360 million pounds were menhaden. By 1964 the processing plants closed. Over-fishing had depleted the menhaden and plants, boats, and their workers were idled. The industry had been killed by its own efficiency.

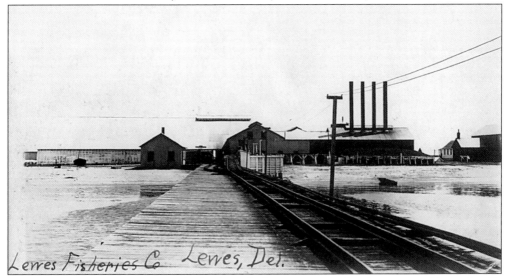

LEWES FISHERIES CO. This was the third menhaden processing plant in Lewes and it was locally owned. In 1938 it was sold to the Smith family and in 1974 the Smiths sold it to Hanson Trust Limited. The site of this building is now Cape Shores.

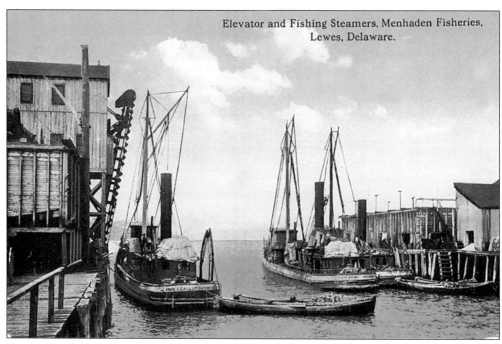

Elevator and Fishing Steamers, Menhaden Fisheries, Lewes, Delaware.

ELEVATOR AND FISHING STEAMERS. This picture shows two of the steamers used to intercept and catch the schools of menhaden. This is probably from the days when the fish had a chance, before aerial spotting. The vessel on the left is the *Anne E. Gallup* of Lewes.

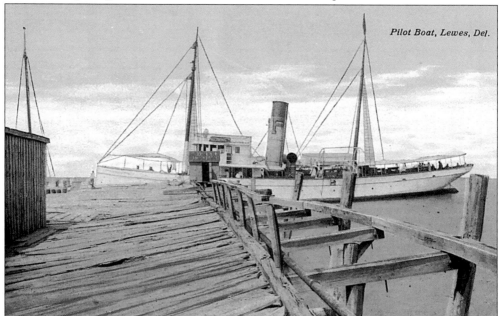

Pilot Boat, Lewes, Del.

PILOT BOAT. Piloting is a highly skilled profession. It requires apprenticeship of three years from graduates of a maritime college or that one holds a third mate's license. Pilots work in rotation, belong to an association, hold a state license, and pool their fees. These go to pay expenses as well as salaries. One of the expenses is a pilot boat on which the pilots eat and sleep until their turn comes to climb the ladder to the deck of the ship that they will pilot up the Delaware.

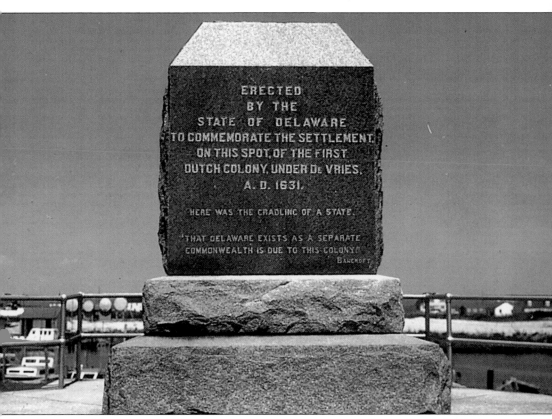

ERECTED
BY THE
STATE OF DELAWARE
TO COMMEMORATE THE SETTLEMENT
ON THIS SPOT, OF THE FIRST
DUTCH COLONY, UNDER De VRIES,
A. D. 1631.

HERE WAS THE CRADLING OF A STATE.

'THAT DELAWARE EXISTS AS A SEPARATE
COMMONWEALTH IS DUE TO THIS COLONY.'
BANCROFT

THE DEVRIES MONUMENT. This monument repeats an error according to Dr. C.A. Westlager, noted Delaware historian. DeVries was the commander of the second voyage to Lewes arriving from Holland on December 5, 1632. He found the fort destroyed by fire and only bleached bones on its site. Apparently no one on this voyage wanted to take the chance of facing hostile Indians, so they all sailed back to Holland, abandoning the effort to establish a colony. The monument marks not a success, but a failure.

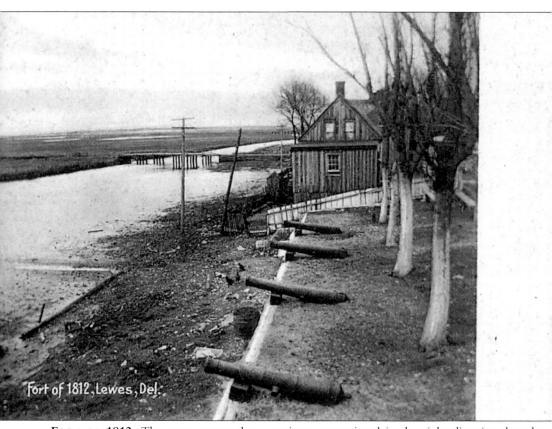

Fort of 1812, Lewes, Del.

FORT OF 1812. The guns, mounted on carriages, are pointed in the right direction, but the trees were not there in 1812. This picture is postmarked 1908 and shows the canal before it was dredged, an earlier bridge, and the lack of development of the beach property at that time.

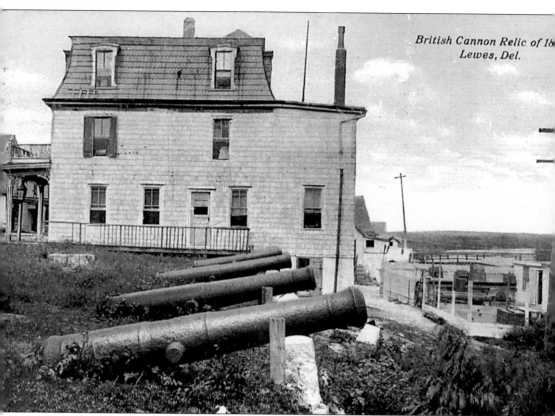

BRITISH CANNON RELIC OF 1812. These are not British cannons taken at the Siege of Lewes, because no British ships were sunk then. If they are British, they are from the sinking of the *DeBraak* in a squall. The house behind the cannon is the Maritime Exchange Building. The Market Street Bridge is visible in the background right.

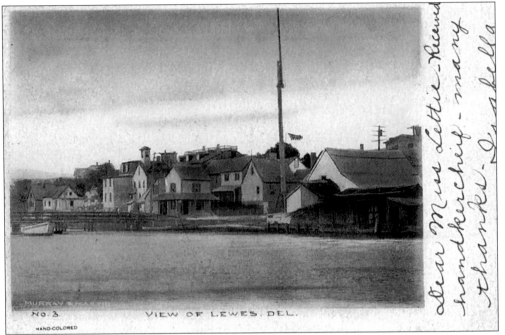

VIEW OF LEWES. This card is postmarked September 1907. It was published by Murray and Martin. Shown in this photograph is the Market Street Bridge, which was in use from 1775 to 1914, when dredging for the construction of the canal required its removal.

FRONT STREET FROM SOUTH STREET.

No. 478 Published by The Central News Company, Philadelphia Pa.-Leipzig-Berlin

FRONT STREET. This is Gills Neck Road. The postcard, which was printed before the City Council changed the street names back to their original names, shows the houses and their claims to ownership of the canal.

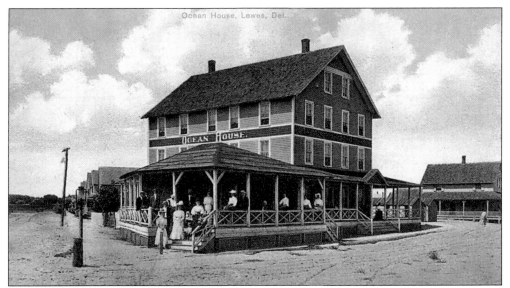

OCEAN HOUSE. This Ocean House was originally owned and managed by Clarence Beebe and, later, by his son, Charles. This was the second of its name and was originally built about 1900 at the corner of South Street (now Savannah Road) and Bay Street at a cost of less than $100. According to a 1901 advertisement, guests for a week or longer paid only $1.50 a day and were charged $1.00 a day extra for a private parlor. The length of the women's dresses, the fact that the streets are not shelled, and the divided-back card point to a 1908 date. The sidewalk on South Street goes as far as one can see, suggesting the Town constructed it. Condominiums now occupy the site.

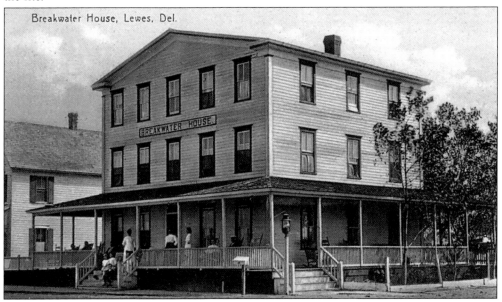

BREAKWATER HOUSE. The Breakwater House was built about 1876 at the corner of Bay Avenue and Market Street. Capt. Ed Gray and his wife Lena were long time operators. A porch screened with cheesecloth faced east. Sumptuous meals were provided; the seafood was purchased from Rickards and Ramsey. The then mayor of Lewes, Dr. Hocker, and his family were frequent guests. Today, condominium units are on the site.

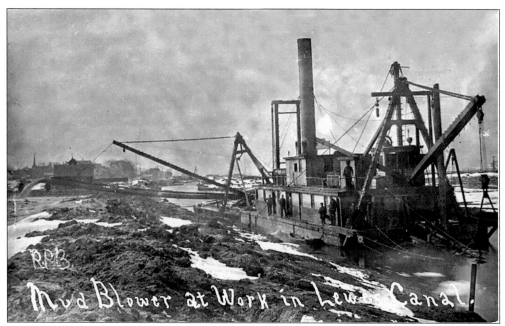

MUD BLOWER AT WORK IN LEWES CANAL. The idea of connecting Lewes Creek to Rehoboth and points south had persisted for many years but had never gotten beyond the talking stage until Congress approved the proposal and work started in 1912. This card is postmarked April 10, 1914, and is part of the construction effort. By 1917 work had been completed so that the minimum usable depth was about 5 feet, except for one 900-foot stretch with a 3-foot depth, and the canal was usable. In 1935, under Roosevelt, additional work was authorized as a Works Progress Administration project and the canal was widened and deepened.

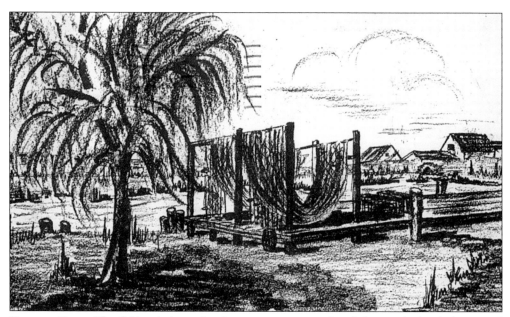

DRYING NETS. The fishing industry has in some measure replaced the menhaden industry and has added employment and income for Lewes's people.

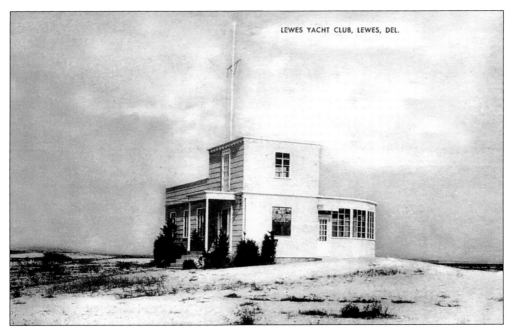

LEWES YACHT CLUB, LEWES, DEL.

LEWES YACHT CLUB. In May of 1937 the yacht club organized and voted to erect their clubhouse on the north side of the Lewes-Rehoboth Canal, near its mouth. You can see from the picture that the clubhouse was not palatial and parking was not provided around it.

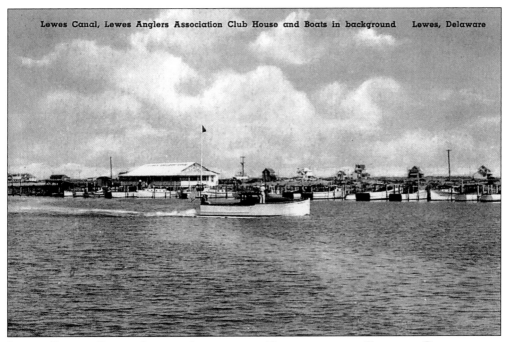

Lewes Canal, Lewes Anglers Association Club House and Boats in background Lewes, Delaware

LEWES CANAL—LEWES ANGLER ASSOCIATION CLUBHOUSE AND BOATS IN BACKGROUND. This picture shows the effect the finished canal has had on Lewes. The Roosevelt Inlet is now connected to the Delaware Bay. Fishing boats are available; private boats can use the docking facilities and have their own association, which has had a vast effect on Lewes tourism.

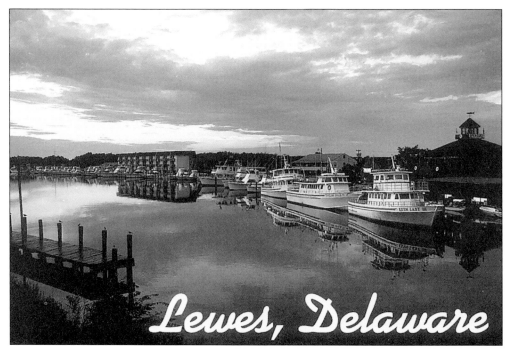

LEWES, DELAWARE. The water in the canal is so still that the boats on the right look as though they are in dry dock. The three story apartment house looks like six. What breeze there is from the south can be seen on the wind gauge on the tower to the right. This card is distinguished by its photography with its range of blues.

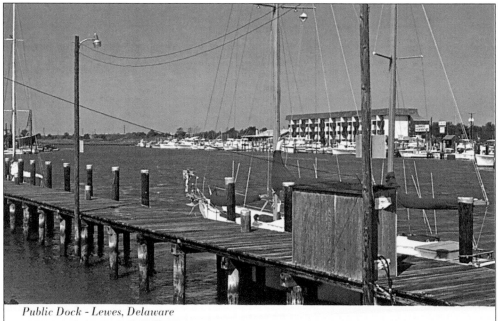

Public Dock - Lewes, Delaware

PUBLIC DOCK. This picture portrays the foot of Savannah Road near Roosevelt Inlet. Docking spaces for yachts and an apartment house are in the background. (Courtesy of Marketplace Merchandising. Photo by Kevin N. Moore.)

24

Two

Lewes Before 1920

The early postcard history of the land development of Lewes begins with the time that electricity came to town, about 1900. Let us take up our tale about the same time, with the gazebo built for Capt. Arthur Hudson, and continue 20 years.

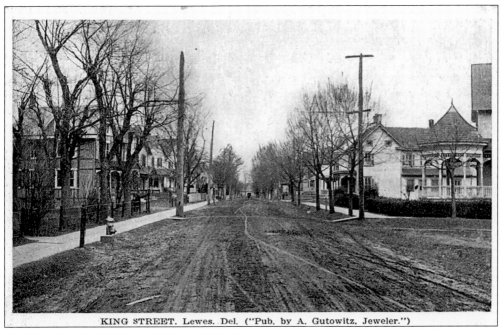

KING STREET. Lewes. Del. ("Pub. by A. Gutowitz, Jeweler.")

KING STREET. King Street was unpaved when this picture was taken, although water, telephone, electricity, and concrete sidewalks had come to town. A gazebo was one way of flaunting wealth and prominence and the maintenance of it intact is no less so today. It may be seen at No. 525 King's Highway, now a bed and breakfast. The house at left, No. 524, was the home of Thomas Groom, superintendent of the Junction and Breakwater Railroad.

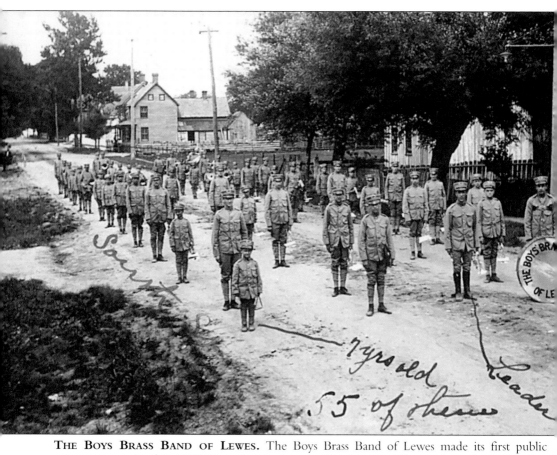

THE BOYS BRASS BAND OF LEWES. The Boys Brass Band of Lewes made its first public appearance on April 5, 1907. The adult leader was Mr. Freeman. The uniforms look like they were modeled on the Spanish-American War uniforms. Apparently the band ran into difficulties because a newspaper reference stated that the band was facing reorganization in 1914. This picture was taken on South Street (now Savannah Road), at that time an unpaved street, with all 55 members, ranging in age from 7 to 16, in attendance. Notice that the seven-year-old is carrying his triangle.

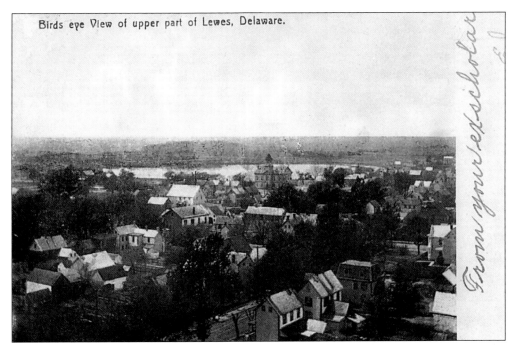

Birds eye View of upper part of Lewes, Delaware.

BIRD'S EYE VIEW OF LEWES. This card is postmarked September 30, 1907. This northwest view shows King's Highway in the foreground, Savannah Road in the center with the wooden school on it, and Blockhouse Pond in the background, stretching from left to right.

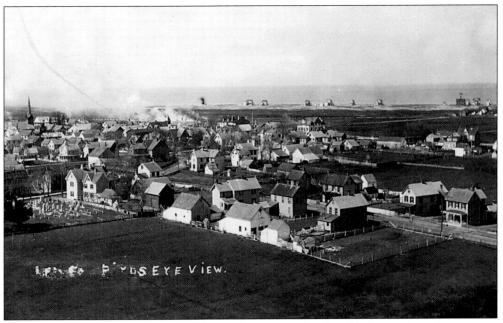

LEWES BIRDS EYE VIEW.

LEWES—BIRD'S EYE VIEW. This is most likely the second earliest bird's eye view of Lewes ever made. It seems King Street is the closest street with a Presbyterian cemetery in the foreground. St. Peter's Church and steeple are in the left background, with the school in the center background on Savannah Road. Blockhouse Pond is in the far background.

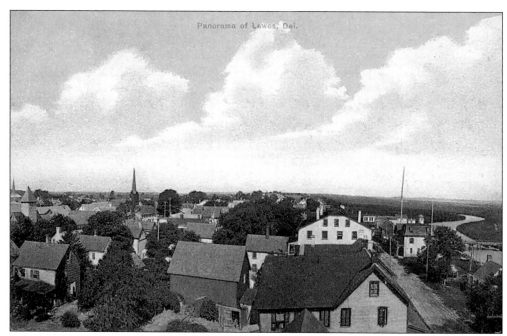

PANORAMA OF LEWES. The Market Street Bridge, which crosses the canal, is on the right. The white house on Front Street is the Virden House that was destroyed by fire. The card was mailed on September 22, 1909, Lewes Day.

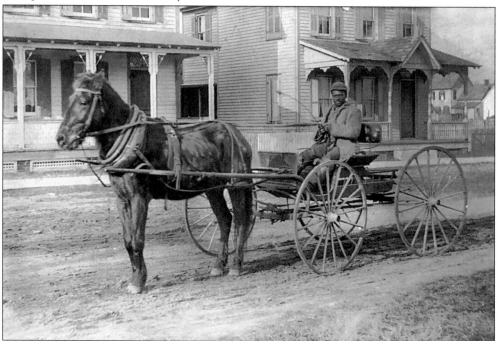

PARKER ROLLIE. This picture shows Parker Rollie with his horse and buggy. Parker was the odd-jobs man of Lewes in the early days of the 20th century. He did the hard and dirty jobs that no one else wanted to do, served the widows and the elderly, and was never covered by Workmen's Compensation.

t tOW r LEWES DEL.

*Merry Christmas &
Happy New Year.*
L.V.

PILOTTOWN. The Queen Anne's Railroad began operation in 1898. This card with an undivided back went out in 1908 and therefore must have been made during that period. The railroad had an office and a turntable close to Pilottown Road. Volume 5, page 80 of the *Journal of the Lewes Historical Society* identifies the houses on the west side of the road, from left to right, as belonging to Chambers, Thomas Virden, T.H. Carpenter, and Bertrand. The three houses on the right have tall windows on the third floor that a booklet on Victorian architecture says "provided lookouts" from which pilots could scan the horizon for incoming vessels.

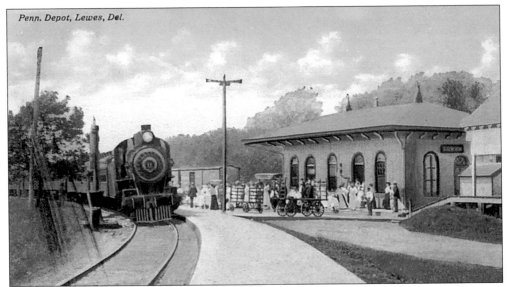

Penn. Depot, Lewes, Del.

PENN DEPOT. This card shows an H6 locomotive, which came into use about 1906. This corresponds to the 1911 postmark. The railroad reached Lewes on March 1, 1898. It was acquired by the Pennsylvania in 1905 and was incorporated as the Maryland, Delaware, and Virginia Railroad, which was locally called the "Many Dirty Visits."

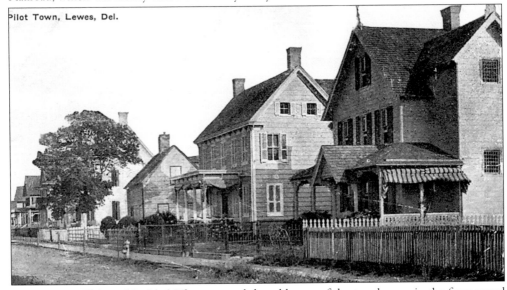

Pilot Town, Lewes, Del.

PILOTTOWN. This card is titled Pilottown and the addresses of the two houses in the foreground are 258 and 260 Pilottown Road. The one on the right has been vacant for a considerable time, and the asking price is $995,000. The two windows on the right wall are unusual, consisting of small square panes of glass. The second house on the left is the home of Michael and Marguerite Codi, who have been residents for more than 20 years. It was formerly the home of a Captain Marshall, a pilot. The house dates from about 1900 according to the Codis. Mrs. Codi has a document dated 1928 granting an easement to the Federal government from Captain Marshall for the land between the road and the creek. She said they now lease it from the City of Lewes. The small house next to the Codis is no longer there. It was allegedly moved away and replaced by the present larger house.

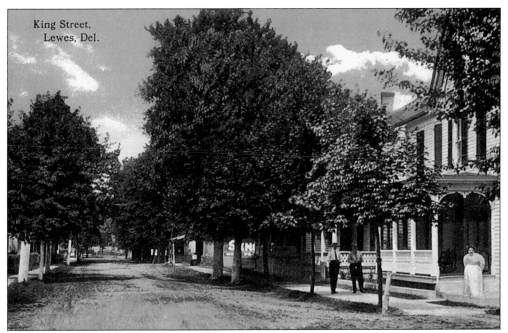

King Street,
Lewes, Del.

KING STREET. This is the house at 439 King's Highway. The property belonged to Charles Shellinger, mayor of Lewes in 1913, for many years, but he sold it to Joseph M. Metcalf in 1916. Whether the woman standing on the right is Mrs. Shellinger or Mrs. Metcalf is debatable. This is an unused postcard.

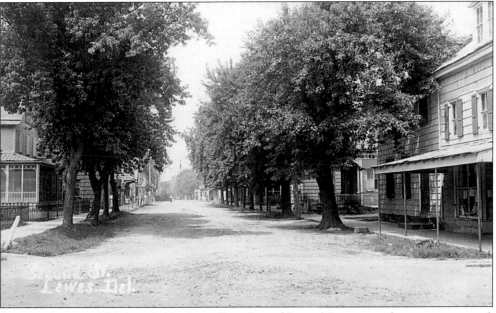

SECOND STREET. This is probably the earliest view of Second Street ever shown on a postcard. There is one store in the right foreground and at least two more in the middle background on the left side of the street. All the rest of the buildings are residential. The doctor's office is on the right side of the street. There is no sign of electricity or telephone except for a hanging traffic control signal in the background, suggesting a date around 1902.

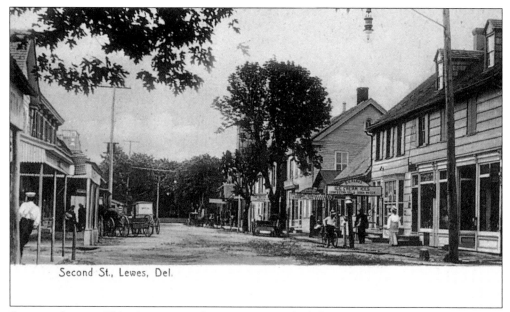

Second St., Lewes, Del.

SECOND STREET. This picture was taken *c.* 1905. On the left is Elmer Outten's Lyceum, which was the theater built in 1896, his drugstore, and department store. On the right is the Rodney complex and David Parks's Ice Cream Shop. All of the vehicles are horse-drawn. But, as the dangling street light suggests, electricity has come to Lewes.

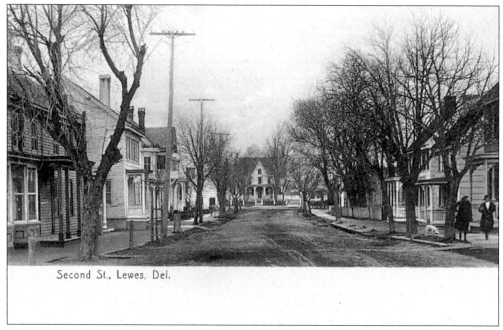

Second St., Lewes, Del.

SECOND STREET. This is the third block of Second Street. It is past St. Peter's Church. Dr. Hiram Burton's home and office, now the home of the Lewes Historical Society, are at the end of the street. For the residents of the other homes, see the centerfold of Volume 2 of the *Journal of the Historical Society*.

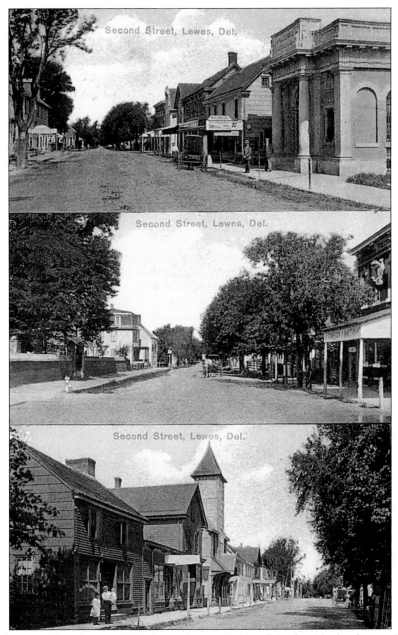

SECOND STREET, TOP PHOTO. This shows the north side of the first block of Second Street. To the right is the Lewes National Bank, which was built in 1902 and torn down in 1967; its name was changed eight times during that period. The photo also shows W. Ebe Lynche's ice cream store and restaurant and the post office, dating this picture before 1916.

MIDDLE PHOTO. This is the second block of Second Street. On the right are the Scott Building and the men's clothing store of Thompson and Manning. The street narrows and the wall of the Episcopal Church and Rectory is on the right. In the background is the Ryves Holt House.

LOWER PHOTO. This photograph shows the Masonic Temple, the Lyceum, and Elmer Outten's Drug Store and Emporium. George Burton's store and Gutowitz's Jewelry are in the background.

33

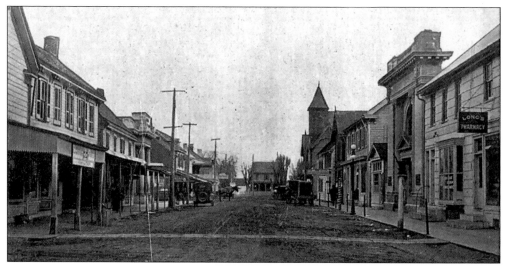

MAIN STREET. Second Street was the principal retail shopping street of Lewes by World War I. A. Gutowitz's Jewelry was located on the west side of the street in the second store this side of the Masonic Temple, the three-story building with the peaked roof. The one-story building is the barbershop; its sign can be seen in front of the tree planted in the sidewalk. The Second Bank, now Wilmington Trust, is next and Long's Pharmacy is the closest. On the east side of the street is the Lewes National Bank, now the Mellon Bank. The horse and horseless carriage share the street. The date is about 1910.

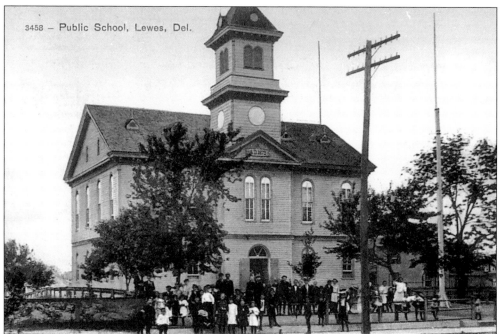

3458 – Public School, Lewes, Del.

PUBLIC SCHOOL. The Lewes Union School was built in 1875. It contained seven classrooms and an office. There were six female teachers and a male principal. All grades through high school were taught. At that time there were only the 9th and 10th grades in high school; the 11th grade was added in 1894 and the 12th in 1898. The school graduated its first senior class of four girls in 1879. Beebe Hospital now occupies the site.

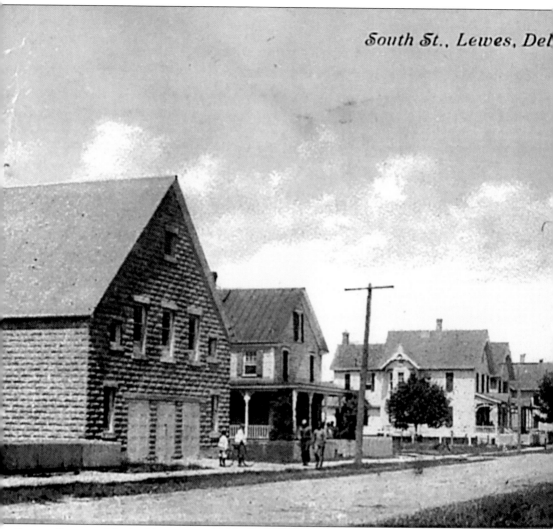

South St., Lewes, Del

SOUTH STREET. The building to the left with three doorways in front was built as the town hall. It was later a moving picture house when it caught fire and burned to the ground.

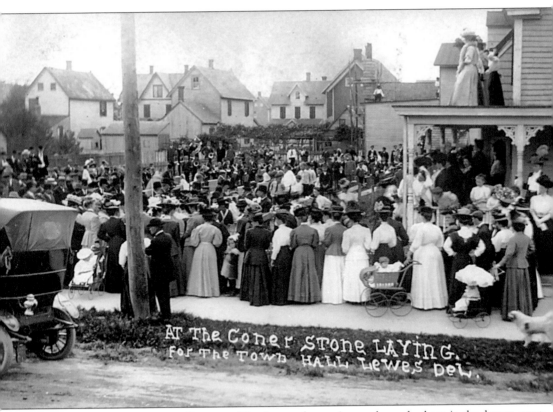

AT THE CORNERSTONE LAYING. The house shown in use by onlookers is the house next to the Town Hall-Movie Palace shown in the previous picture. There is a tremendous crowd gathered for the cornerstone laying on May 28, 1908. It was an occasion for the town—their first town hall.

ST. PETER'S EPISCOPAL CHURCH.

The parish was founded about 1682. The first church was built in 1791 and the present church in 1858. The first church was moved to a farm and used as a farm building. It was destroyed by Hurricane Hazel. The church is located on Second Street and is surrounded by a brick wall.

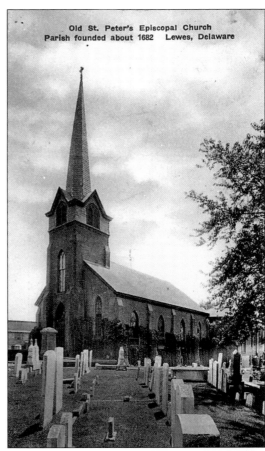

Old St. Peter's Episcopal Church
Parish founded about 1682 Lewes, Delaware

THE PRESBYTERIAN CHURCH.

The Presbyterian Church in Lewes relies on a deed from the Court of Common Pleas dated May 6, 1707 for its beginning. The deed was for a hundred square feet for a meeting house, school house, and burial place. The first church was built in 1707; the first brick church was built in 1727 and torn down in 1871; the present church was erected and dedicated in 1832. The steeple was added in 1886 and was calculated to hold a 1,000 pound bell. In recent years the steeple was removed and the bell lowered in a general renovation.

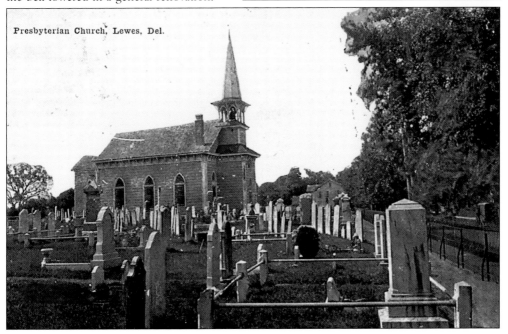

Presbyterian Church, Lewes, Del.

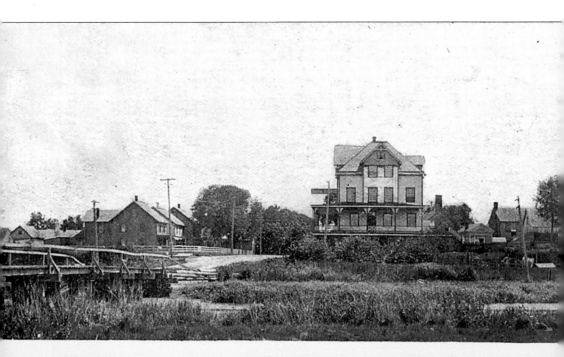

A view of South Street from Lewes Beach, Lewes, Del.

A VIEW OF SOUTH STREET FROM LEWES BEACH. In the center of the picture is the Caesar Rodney Hotel, which was built *c.* 1890 and was located at the corner of South and Front Streets. This card, presenting the center of Lewes, is postmarked August 17, 1907. The bridge over the creek appears to be a simple wooden one without any lift. The house on the opposite corner appears to have a fence that runs on South Street and continues down Gill's Neck Road.

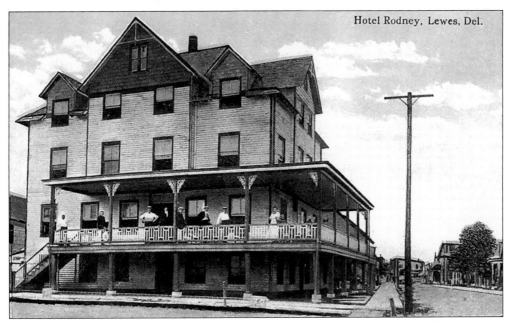

THE RODNEY HOTEL. The hotel was built around 1890 and was located at the corner of Savannah Road and Front Street. On January 29, 1925, it was about 7 degrees outside with a 40-mile-per-hour wind shaking the hotel when Stanton Pierce, the proprietor, smelled smoke and investigated. He found the hotel was on fire and attempted to evacuate his 20 guests. One of them was eating breakfast and insisted on finishing it. Firemen were called and the call was passed on to surrounding towns for assistance. The building collapsed about 10:30 a.m. and the fire became uncontrollable. The Laurel firemen who were there by then and who had the largest pump climbed on a garage roof and pumped water from the canal. Wind driven hot embers were flying over the town and homeowners were busy stamping them out. Charles Mitchell, a fireman of Laurel, was the only one injured; he suffered a frozen finger.

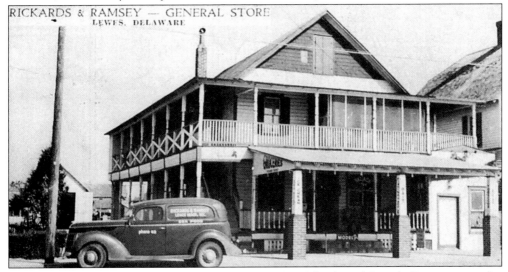

RICHARDS AND RAMSEY GENERAL STORE. Lewis Rickards and Joseph Ramsey owned a grocery business between 1919 and 1973. They must have given excellent service and made prompt deliveries that enabled them to last that long without modernizing.

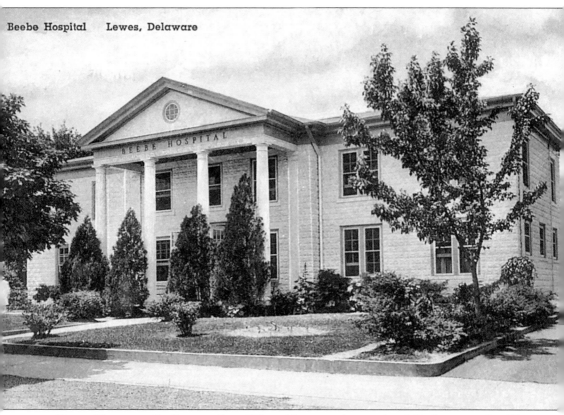

BEEBE HOSPITAL OF SUSSEX, INC. When this postcard was printed, Beebe was truly of Sussex; its patient draw was countywide. The hospital had the only nursing school south of Wilmington. It had an expansion drive in 1985 and another is underway. The hospital is fully accredited and is the largest employer in Lewes. It is the center star in Lewes's crown. The late doctors James and Richard Beebe opened the doors in 1916 with three beds and an operating room.

Three

LEWES IS GROWING

Lewes is a town that fell into a slumber, then, when jarred awake, looked around and was appalled by what it saw. It formed a historical society, put an end to the destruction of its older structures, started venerating its long history, developed a fondness for its Victorian architecture, and began to brag about it.

Its residents began the restoration of its colonial past and when they had exhausted the supply of colonial homes already in town, they scouted the countryside for more, moved them to lots in town, and painstakingly restored them. Such activities have paid dividends in property values, in multiplication in the number of visitors, and in satisfaction with a job well begun.

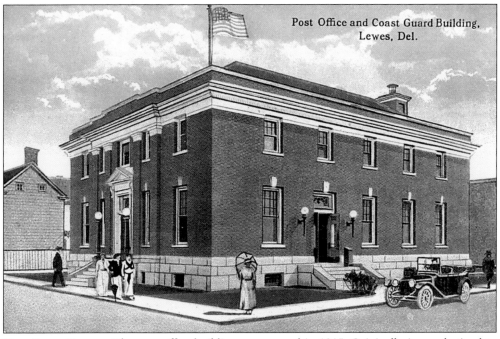

Post Office and Coast Guard Building, Lewes, Del.

THE POST OFFICE. The post office building was opened in 1915. Originally, it was destined to be used jointly by the Coast Guard and postal service. This card was published by Gutowitz, the jeweler, and the automobile and the women's dresses are dated *c.* 1915.

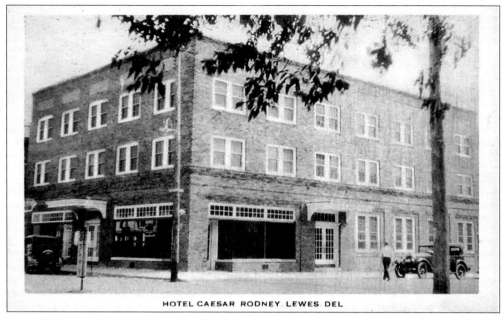

HOTEL CAESAR RODNEY LEWES DEL

HOTEL CAESAR RODNEY. After the original Hotel Rodney burned in 1925, there was no longer a year-round place of accommodation for visitors to Lewes and a new hotel was deemed necessary. The sprawling Rodney structure at the corner of Second and Market Streets was acquired by the Lewes Hotel Company, Incorporated, and the Caesar Rodney Hotel was erected. Since then it has born the name Swan's Inn and, since 1989, has been called the New Devon Inn. For a number of years it also contained the town hall until a municipally owned one was built on Third Street in 1961.

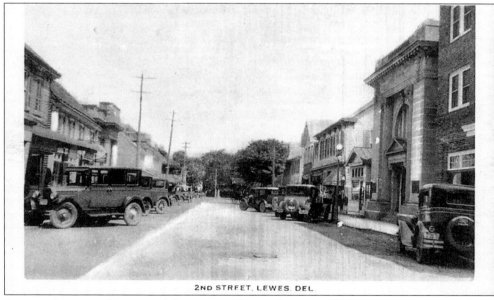

2ND STREET. LEWES. DEL.

SECOND STREET. This postcard shows a paved Second Street in the late 1920s. Note the wooden telephone poles. The Caesar Rodney Hotel has been built and can be seen next to the Sussex Trust Company. The old Masonic Building, which burned in 1920 and was replaced in 1925, is on the west side of the street. Parking meters had yet to appear.

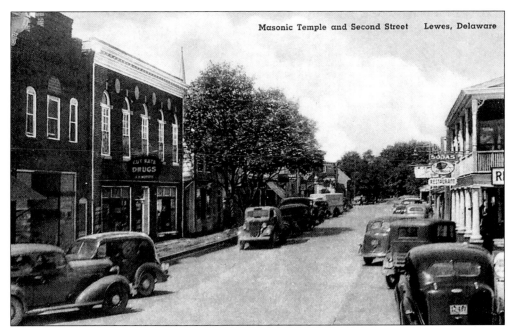

MASONIC TEMPLE AND SECOND STREET. This card was made about 1925. If the cars were parked like that today the police force would have ticketed all of them. Outten's Lyceum is on the left and the new Masonic Temple is next to it, the first floor of which is occupied by Arthur W. Morris, pharmacist. The building on the right is still a restaurant.

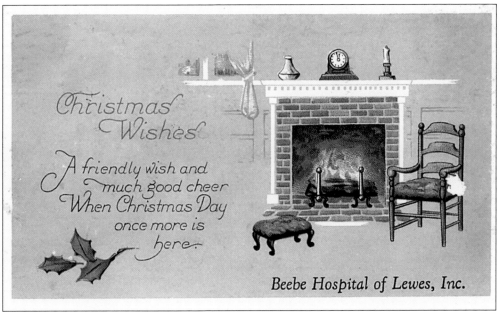

CHRISTMAS WISHES. This postcard is unusual—it is the first Christmas card from a hospital we have ever seen. It was mailed in 1928 to a couple living in Dagsboro, Delaware. What are Christmas wishes from a hospital? Stay well? Congratulations on the birth of a child? We appreciate your business? Come again?

43

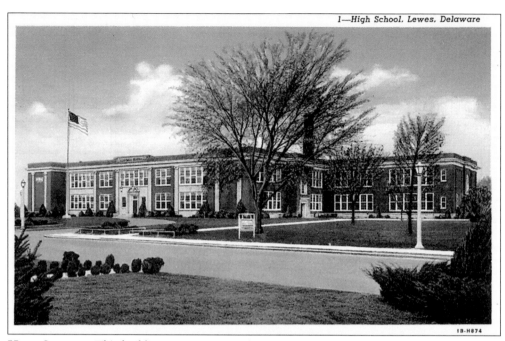

1—High School, Lewes, Delaware

HIGH SCHOOL. This building was constructed in 1921, a wing was added in 1932, and a new high school was built in 1976. At that time, this school became the middle school.

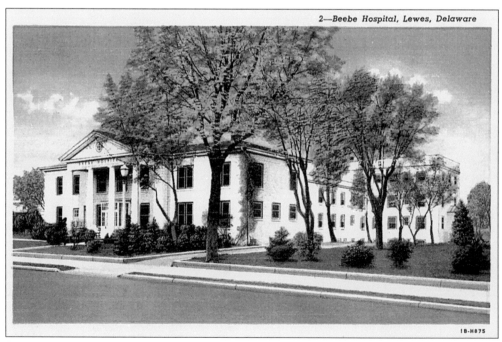

2—Beebe Hospital, Lewes, Delaware

BEEBE HOSPITAL OF LEWES, INC. Where does the warm friendly small-town feeling stop? When you change your name. It was still Beebe of Lewes in 1928 when the hospital sent out Christmas cards, but it was Beebe Hospital of Sussex when it became a 150-bed hospital and had to rely on gifts from a larger area.

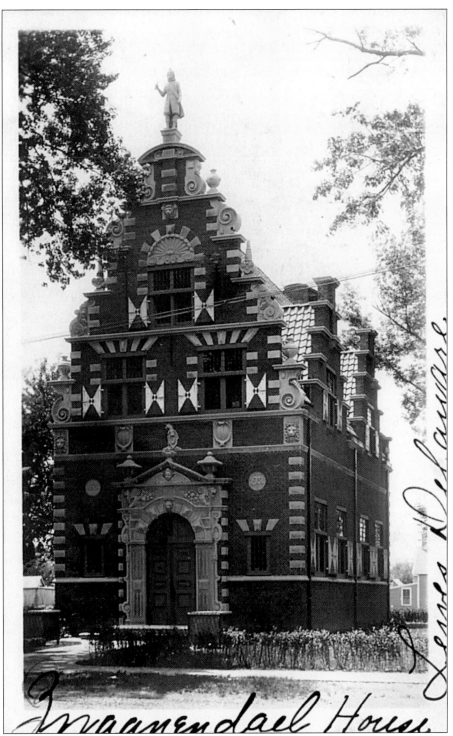

ZWAANENDAEL MUSEUM. A replica of the town hall in Hoorn, Holland, the Zwaanendael Museum was erected by the State of Delaware in 1931 to commemorate the 300th anniversary of the first Dutch settlement. It has a growing collection.

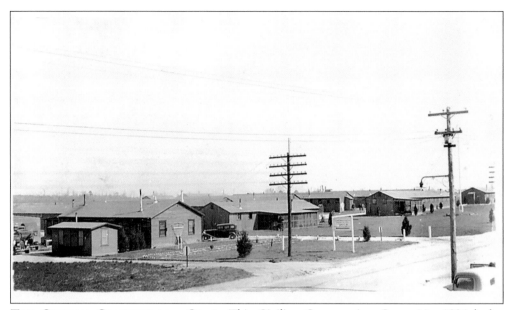

THE CIVILIAN CONSERVATION CAMP. This Civilian Conservation Camp No. 1224 had a mosquito control project at Lewes. The camp, located on Savannah Road south of the railroad tracks, closed on September 30, 1937 but was reopened during World War II as a prisoner of war camp with minimum security.

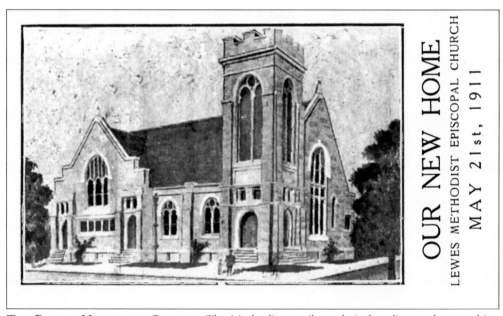

THE BETHEL METHODIST CHURCH. The Methodists attribute their founding to the preaching of George Whitefield who came to Lewes in 1739. He arrived by ship on October 30th and preached the following day. The following May he came to Lewes and preached to about 2,000 people. Bishop Francis Asbury noted in his diary in October, 1790, "that we have a chapel built at Lewistown." The present church was dedicated on May 21, 1911.

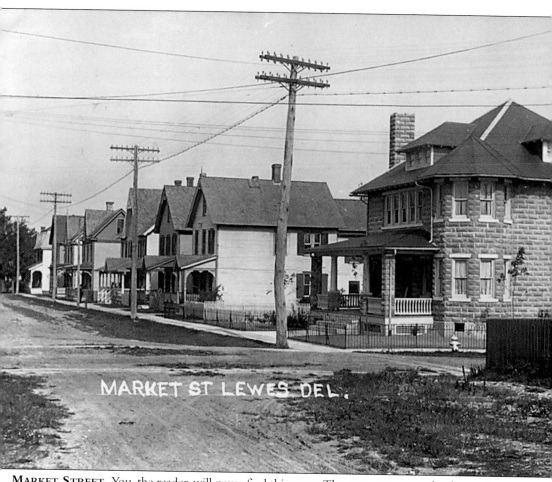

MARKET STREET. You, the reader, will never find this scene. The corner property has been taken over by an expanding Methodist Church. Some of the houses are still in existence.

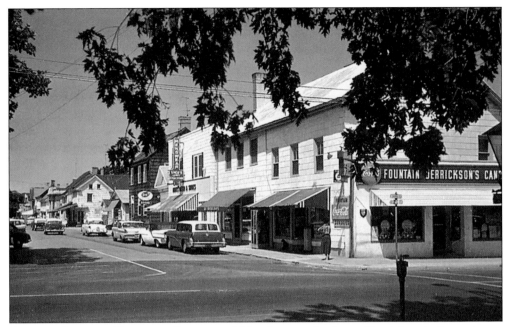

SECOND STREET—BUSINESS SECTION. This photograph shows Derrickson's Fountain on the corner, with a menswear store and a bookstore behind it. The Buttery Restaurant is across the street.

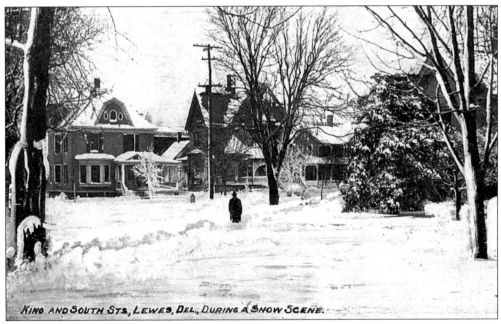

KING AND SOUTH STS, LEWES, DEL., DURING A SNOW SCENE.

KING AND SOUTH STREETS. This card is postmarked August 1911, so the picture was taken the previous winter at the latest. The house at left was the home of Dr. Robinson, the second belonged to Chick Johnson, the third was the home of Charles Morris, and the fourth was the home of Dr. William P. Orr.

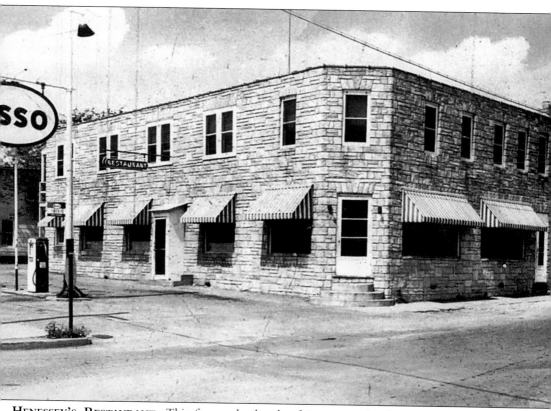

HENESSEY'S RESTAURANT. This former landmark of Lewes caught fire and burned to the ground on December 31, 1970. It was a longtime restaurant that opened around 4:00 in the morning to feed the fishermen. It was located on Savannah Road and Franklin Street.

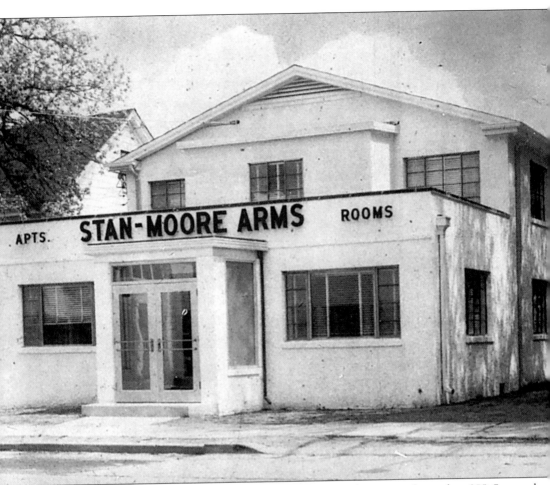

THE STAN-MOORE ARMS. This bedroom and apartment house was located at 109 Savannah Road. It was a year-round spot for people who wanted neat and clean hotel accommodations. It is now the location of the Schooner Inn.

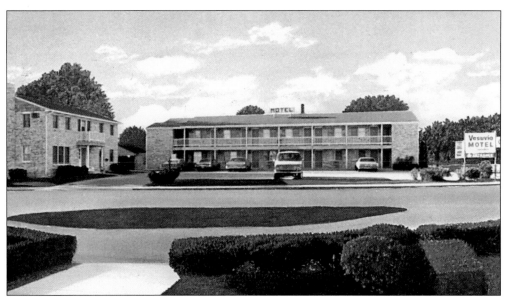

Vesuvio Motel. This building is at the corner of Savannah Road and Gill's Neck Road. It is run by Gennaro and Margaret Iacono. The restaurant is in the building on the left.

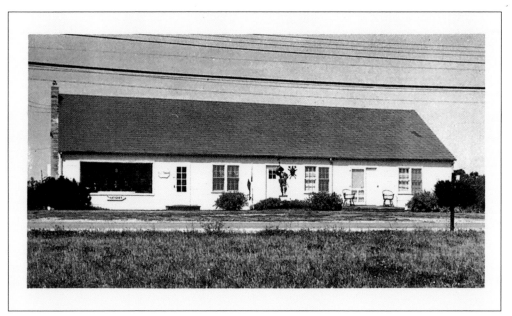

The Vogan House. Once owned by Scott and Marie Vogan, this property is located at 800 King's Highway and is presently occupied by Caldwell Bankers. Three dormer windows have been added, which make the roof look shorter.

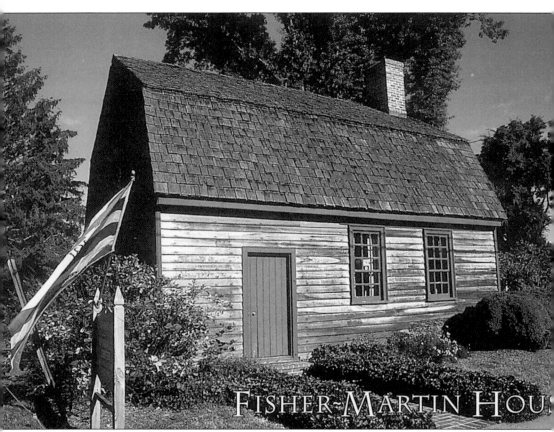

THE FISHER-MARTIN HOUSE. This house is an example of a 1730 home. Built in Coolspring, it is an example of the movement and restoration of old houses. The house was owned by Joshua Fisher, who charted Delaware Bay, and was later tenanted by Rev. James Martin, who founded Coolspring Presbyterian Church. It was moved to Lewes in 1980 as part of the 300th anniversary of the town. It is now the home of the chamber of commerce. (Courtesy of Marketplace Merchandising. Photo by Kevin N. Moore.)

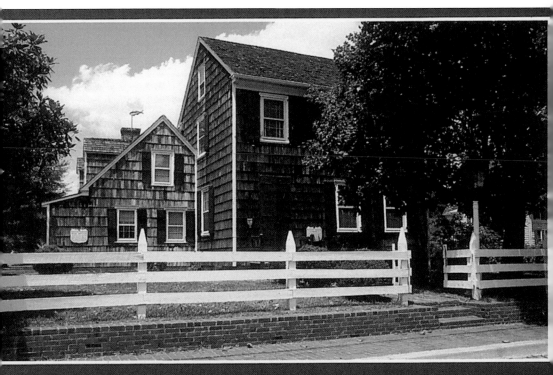

BURTON-INGRAM HOUSE

BURTON-INGRAM HOUSE. Built in the 18th century on Second Street at Neil's Alley, the Burton-Ingram House was sold in 1962. The new owners presented it to the historical society, who moved it to its present location on Ship Carpenter Street. The present south wing has been added from another house of the period; it has been restored and refurnished by the society and is now open to the public. (Courtesy of Marketplace Merchandising. Photo by Kevin N. Moore.)

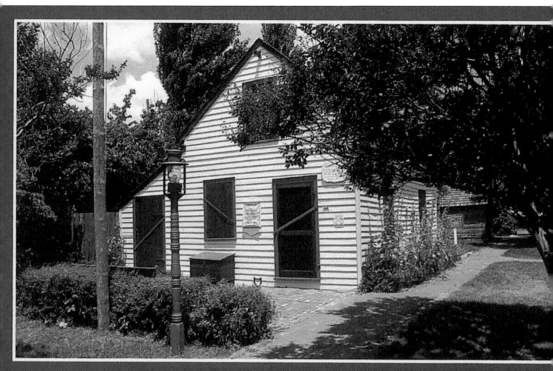

THOMPSON COUNTRY STOR

THOMPSON COUNTRY STORE. The Thompson Country Store is one of the buildings moved into town by the Lewes Historical Society. It was built in Thompsonville, Delaware, *c.* 1800 and was operated by the Thompson family until 1962 when it was acquired by the society, moved into town, and re-opened with old stock. (Courtesy of Marketplace Merchandising. Photo by Kevin N. Moore.)

Four

GEORGETOWN IN 1885

We are fortunate to have a copy of a lithograph of Georgetown and have cut the copy in half for this book, as you can see on the following pages. In addition we have added pictures of buildings that were here in 1885, the date of the lithograph. The lithograph was drawn to scale and the important buildings were numbered by O.H. Bailey. He charged extra for views of buildings drawn on the scene in a larger scale and added to the lithograph. Copies were sold for probably $1 a piece. He captured Georgetown for all time—before photography.

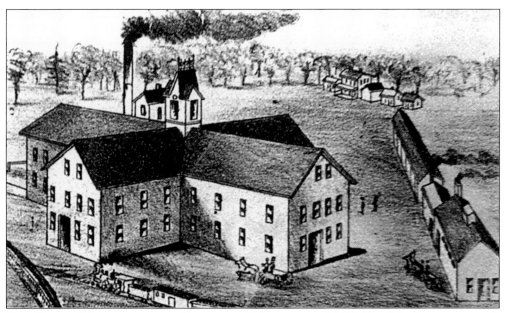

THE SUSSEX MANUFACTURING COMPANY. This was one of C.H. Treat's business ventures. It was a lumber business, producing sawed lumber, shingles, lath, packing boxes, and cooperage. The Sussex Manufacturing Company was complementary to his butter dish business and the officials were outsiders. It went down with the rest of Treat's empire in 1889.

55

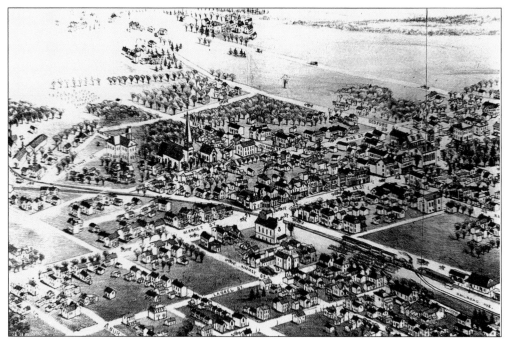

GEORGETOWN IN 1885 LITHOGRAPH. A group of artists in the 1880s drew pictures of towns as their livelihood. O.H. Bailey was one of them. He arrived in town, located a point from which he could draw a picture of all the buildings, and drew them all to scale. Bailey laid out the streets and shrubbery, the train and tracks; he even put traffic on the streets and smoke in the smoke stacks. When the picture was completed, he took orders for copies, sold copies to merchants of their stores and plants, and made arrangements with one merchant in town to sell extra copies of the entire drawing. C. H. Treat possibly brought Bailey to Georgetown since all his businesses were included in the added pictures.

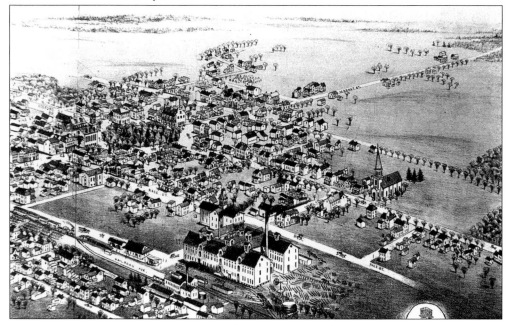

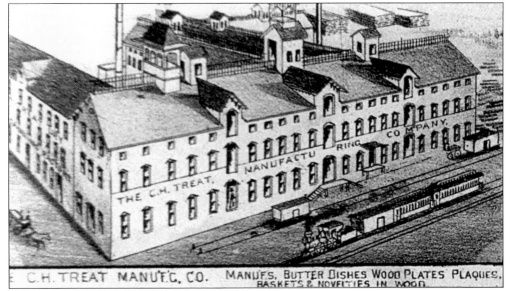

C.H. TREAT MANUF'C. CO. MANUFS. BUTTER DISHES WOOD PLATES PLAQUES. BASKETS & NOVELTIES IN WOOD.

THE C.H. TREAT MANUFACTURING CO. Charles H. Treat moved his business to Georgetown in 1883 when he acquired the Fruit Preserving Company plant. He converted it to the C.H. Treat Manufacturing Company and incorporated the business on April 4, 1883, with a capital stock of $100,000. His businesses, including canning, preserving, and manufacturing wooden butter dishes, pie dishes, and other wares, required hundreds of new workers, including women. Treat built homes for his employees and paid one-fourth of their wages in cash and three-fourths in scrip, which was redeemable as rent and purchases at the C.H. Treat New York Store, shown below. This angered the local merchants; they pressured the Farmer's Bank not to increase his credit line. In 1888, Treat was the Republican candidate for Congress; he ran an active campaign, but lost. His incursion into politics angered Democrats, who added their voices to the disgruntled merchants. Treat also hired outsiders as company officials and therefore did not have the locals' friends and families to support his needs. The bank refused him further credit and called some existing loans, resulting in the crash of his empire. Treat left Georgetown in 1889.

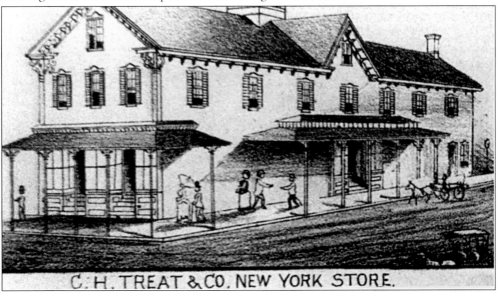

C. H. TREAT & CO. NEW YORK STORE.

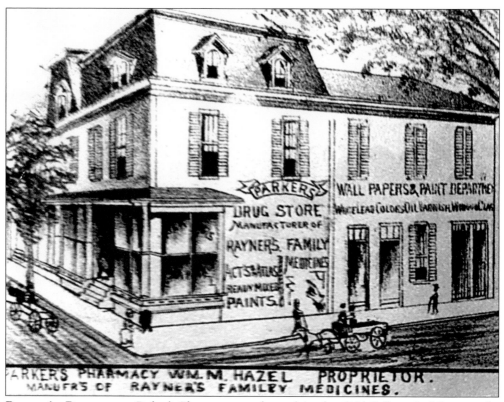

PARKER'S PHARMACY. Parker's Pharmacy was located in the Odd Fellows building on the corner of Market and Race Streets. It was run by William Hazel who had married Parker's widow. He also sold paints and oils and manufactured patent medicines.

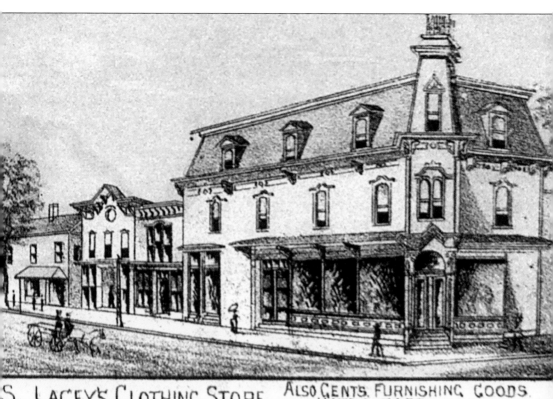

S. LACEY'S CLOTHING STORE. ALSO GENTS. FURNISHING GOODS. HATS & CAPS.

W.S. LACEY. Lacey advertised a willingness to accept railroad ties, lumber, and country produce in exchange for goods. He had a clothing store that was located on West Market Street at the corner of Race Street.

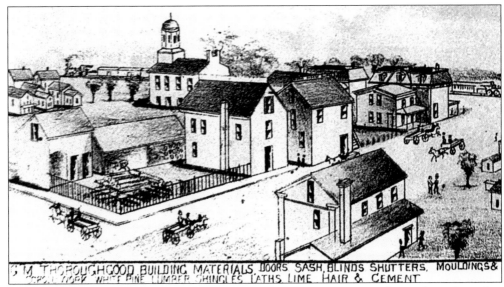

GEORGE M. THOROUGHGOOD LUMBER COMPANY. The George M. Thoroughgood Lumber Company was located on South Race Street and was a retail lumber and millwork company. It also sold cement, lime, hair, shingles, plows, and well pipe. He also drove wells.

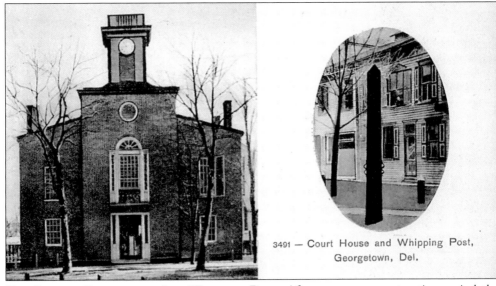

3491 — Court House and Whipping Post, Georgetown, Del.

THE SECOND COURTHOUSE AND WHIPPING POST. After a two-year construction period, the county government moved into its new building in 1859. The building was designed by William Strickland, who was dissatisfied with its unimpressive appearance. It did not cost the taxpayers of Sussex a penny; instead, it was paid for with the proceeds of a lottery. It is difficult to design a government building that is adequate for more than a few decades. What was commodious in 1880 had become inadequate by 1900 and was remodeled and enlarged by 1910. In 1969 the courthouse was remodeled, enlarged, and made more pretentious. The whipping post was used alongside the courthouse until it was abolished in 1905, even though the State Register of Laurel said that it reportedly decreased the number of wife-beaters. In 1932 a new jail was built on the county Poor Farm.

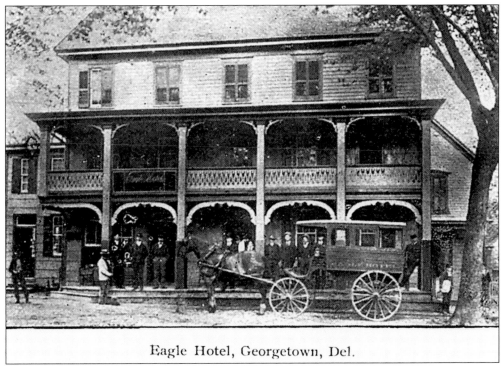

Eagle Hotel, Georgetown, Del.

THE EAGLE HOTEL. The Eagle Hotel was built in 1807 between the courthouse and the corner of South Bedford Street. It retained its popularity for over a hundred years, but was finally torn down when it became too out of date.

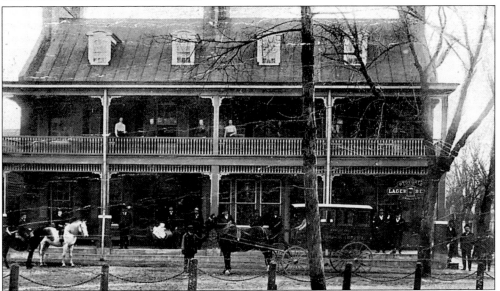

THE BRICK HOTEL. Built in 1836, the Brick Hotel served as the seat of justice when the courthouse was being built and as a post office in 1841, and it was known as the Union Hotel during the Civil War. The hotel was also used as a meeting place for the Rotary Club and other civic groups. It was bought by the Citizen's Acceptance Corporation, which was taken over in 1959 by the Wilmington Trust Company.

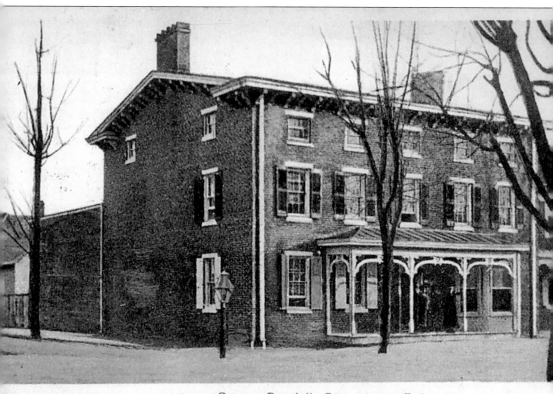

3474 — Sussex Co. Jail, Georgetown, Del.

THE OLD SUSSEX COUNTY JAIL. The Old Sussex County Jail was located on the corner of East Market Street and Cherry Alley. Built in 1835, "a proper regard [was] had to the health of prisoners" during the construction. It was built of brick and was 40 feet by 42 feet and cost $10,000. The jail burned in 1869 and was rebuilt. A porch was added in the 1880s. It ceased to be the county jail in 1932 when a new prison was erected on what had been the county Poor Farm. The jail was not escape-proof. On January 5, 1905, the State Register of Laurel reported that "eight persons had walked out of jail while the Sheriff slumbered."

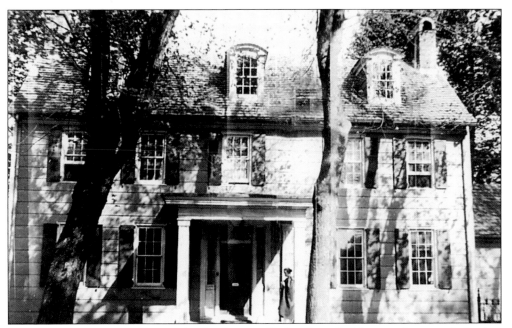

THE JUDGE'S HOUSE. This was the first home of Judge Peter Robinson, who was admitted to the bar on April 23, 1799. Later, it was the home of Judge Edward Wootten, whose wife was a Robinson and who served as judge from 1847 to 1882. Wootten was never reversed on appeal. The house is now owned and occupied by Mr. and Mrs. Robert Houston Robinson. Mrs. Robinson also happens to be a retired judge.

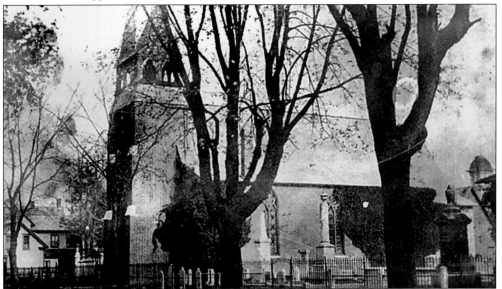

ST. PAUL'S EPISCOPAL CHURCH. St. Paul's Episcopal Church was the first church organized in Georgetown. Organized in 1794, services were held in the courthouse until sufficient funds were available to build a church. The first church was erected after a lottery was authorized for $1,500. The construction was progressed enough to be useable in 1806, but was not completed until 1827. The second church was built of brick on the same lot and was dedicated November 19, 1844. The church was rebuilt in 1881, a pipe organ installed in 1886, and a rectory built in 1897.

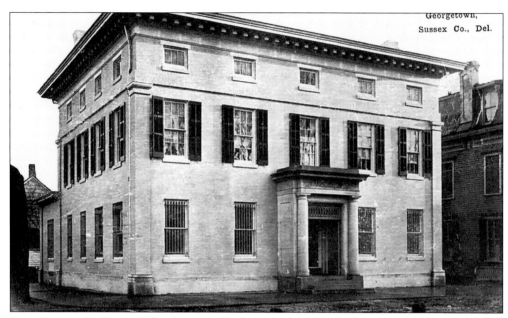

THE FARMER'S BANK. The Farmer's Bank opened its books for subscription on the first Monday in May 1807; 1,600 shares were allotted to Sussex County, with subscribers limited to purchase 20 shares per day so long as the 1,600 had not been fully subscribed. Each purchaser had to make an initial payment of $5 with one-half being in gold or silver and the other half in approved paper money. Each subscriber was required to pay an additional $5 each 60 days until he or she had paid a total of $25 per share. By the end of the first week the entire 1,600 shares had been subscribed by 115 subscribers. Thomas Cooper, an attorney, was the first president of the Georgetown branch and Isaac Tunnell was the first cashier. The cashier received living quarters in the bank building as an additional perk. Ownership of the bank building was acquired in 1835 and continued until 1853 when a new lot was acquired and a new bank building erected thereon; construction was completed in 1857. It was still in use in 1885.

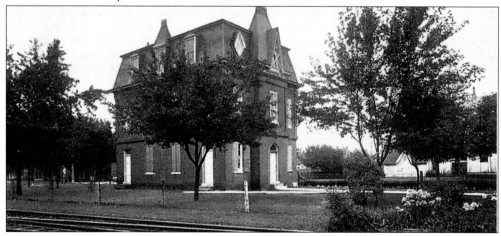

THE MASONIC TEMPLE. This building was constructed as the result of a lottery in 1843. The lower floor was used for an academy and the upper floor for masonry. The academy was a private school and used the building with Franklin Lodge No. 12 for years, but finally closed in 1885 after the railroad came to Georgetown. The tracks, visible in the postcard were alongside the building, and there was much more train traffic in 1885 than there is now.

Five

GEORGETOWN
BEFORE 1930

What contributed most to the growth of Georgetown in the first three decades of the 20th century? Ease of communication, easy visitation, the telephone, paved roads, growth of government, and easy access to it. More people came and, while they were here, transacted other business.

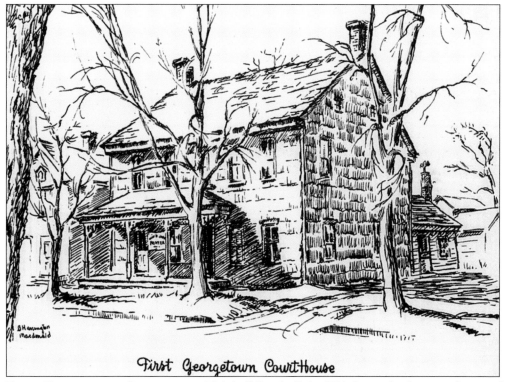

First Georgetown CourtHouse

FIRST GEORGETOWN COURTHOUSE. This building, built in 1791, is not the first courthouse of Sussex County; that was in Lewes. But this is the first one built in Georgetown. It is the oldest existing wooden courthouse in the United States. In the 1830s it was moved off the Circle to a lot on South Bedford Street to clear the site for its successor. At that site it was allowed to sit and fall into gradual disrepair until 1976, when it was moved again and restored.

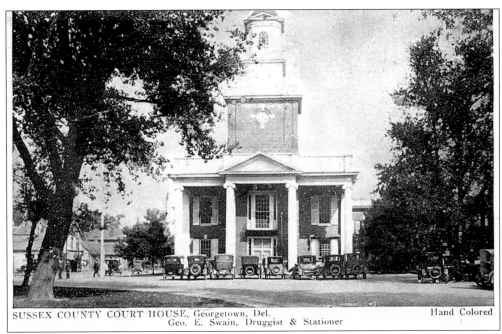

SUSSEX COUNTY COURT HOUSE, Georgetown, Del.
Geo. E. Swain, Druggist & Stationer
Hand Colored

THE SECOND COURTHOUSE. The state legislature passed a bill in 1835 authorizing a $25,000 lottery with $10,000 of the proceeds allotted for a new courthouse. The lottery was successful and the courthouse was authorized in 1837. It was to be a brick two-story building 60 by 50 feet, containing a courtroom, grand and petty jury rooms, and six offices. It was to be built on the old lot, so the first courthouse was moved and the second built in its place.

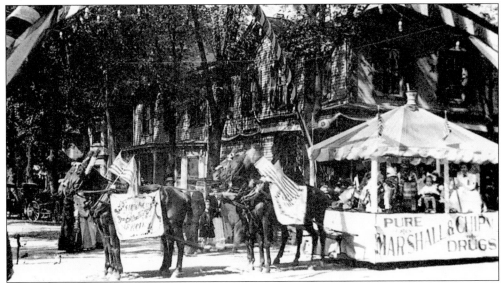

HOMECOMING PARADE, 1908. In late September or early October of 1908, the town council appropriated $25 to a committee that was arranging a carnival. This float belonged to Marshall and Chipman. Chipman, a good businessman, had bought a rival's drug store, Layton and Layton, in 1906, and was competing with Dr. John Hammond, who also had a pharmacy in Georgetown. Chipman used every opportunity to publicize his business. After Chipman's death, his pharmacy was sold to George E. Swain, and Chipman's widow carried on the other portions of the business.

WHIPPING POST AND PILLORY. The Georgetown Historical Society's museum has a picture of the pillory attached to the whipping post, but another photograph in the book *Sixteen Miles From Anywhere*, taken about 1900, is missing the pillory. Therefore, we must surmise that the pillory had been abolished by then, which means this picture is a hoax. Edward Payne, a photographer in Georgetown with a studio on Pine Street, is listed in the 1904–1905 Georgetown Directory and the postcard is postmarked in 1903. It shows a man with his hands upright in the pillory. This would have been cruel and unusual punishment had it been real and not posed; the man's hands would have become numb from lack of circulation. Payne did block out his accomplice's face, but he was smart enough to leave the spectators in the picture.

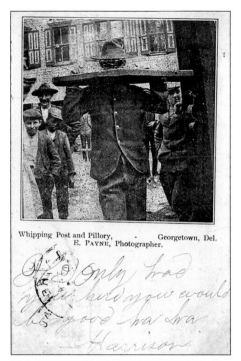

Whipping Post and Pillory, - Georgetown, Del.
E. PAYNE, Photographer.

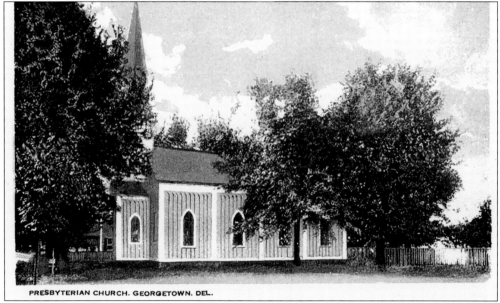

PRESBYTERIAN CHURCH. GEORGETOWN. DEL.

THE GEORGETOWN PRESBYTERIAN CHURCH. Judge Edward Wootten gave the lot for this church, providing that no graveyard be built on the land. The building was completed and dedicated on December 15, 1872. In 1926 the church purchased a building for a manse on South Bedford Street. In April 1934, the sanctuary was elevated, a basement dug for a new kitchen and Sunday school room, and a new roof built. The interior was remodeled next and an electric organ added. In 1946 an education wing was built. The church constructed a new manse and purchased the remaining land on the block in the 1950s. In 1974 the church negotiated a deal with the Town; in return for $1 per year, the land was rented for use as a park.

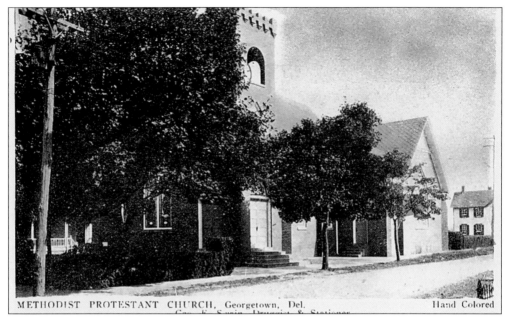

METHODIST PROTESTANT CHURCH, Georgetown, Del. Hand Colored

GRACE METHODIST CHURCH AND PARSONAGE. The Methodist Protestant Church was opened on April 10, 1892, at the southeast corner of Market and King Streets. In 1905 the church was moved across the street and remodeled. It was destroyed by fire in 1909 and rebuilt with a brick exterior. In 1927 it was struck by lightning, caught fire again, was destroyed. The congregation rebuilt and it reopened in 1928.

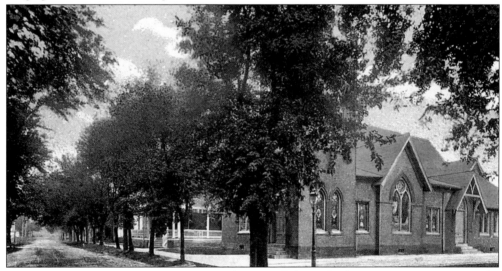

WESLEY METHODIST CHURCH. For 25¢, John Russell donated a lot on Pine Street in 1805 for construction of what is today Georgetown's oldest Methodist church. The building was too small when it was completed in 1838, and six years later the trustees resolved to build a bigger church on Race Street. Money was collected and it was completed in 1865. In 1878, a parsonage was completed. In 1896, the congregation chose to build a new church and purchased additional land on Race Street. On September 10, 1897, a dedication service was held, and the congregation marched to their new church, pictured here. In 1928 the church added a social hall and in 1946 dedicated its carillon bells. An education building was added in 1957 and the sanctuary renovated in 1966.

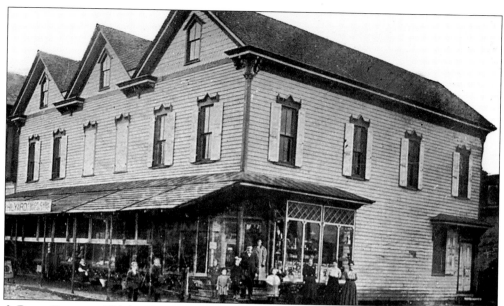

A Busy Corner. This building is at the corner of Market Street and the railroad, but the picture is taken so that the railroad tracks do not show. This store was operated by Walter B. Hilyard who sold only for cash. He offered no credit. Hilyard was a town councilman from 1919 to 1922. He and his family are photographed on the front steps. This building no longer exists; it has been replaced by a mini-market, a vacant lot, and Givens' Flowers.

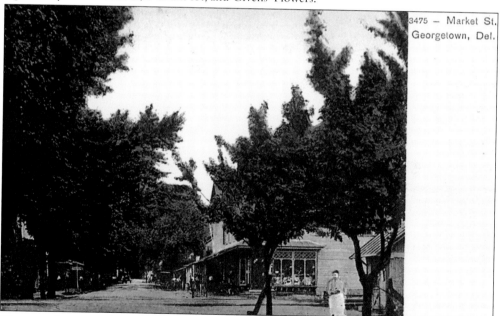

Market Street. This postcard is postmarked in 1908. The railroad tracks can be seen in the foreground, with the Hilyard Store beyond it. The number of trees on both sides of the street, the presence of the horse and carriage, and the dirt street lend an air of placidity to the picture. The trees lasted until May 1935, when a special meeting of the town council was held to decide their fate. The council decided that the trees must go and the street widened; they petitioned the State Highway Department asking that no time be lost in completing the tree removal.

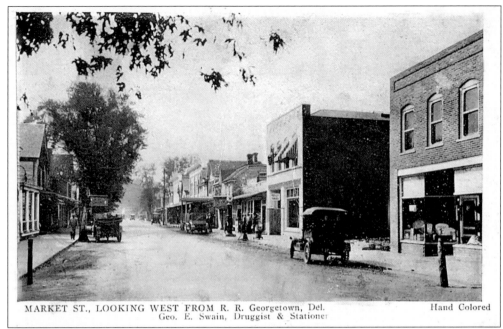

MARKET ST., LOOKING WEST FROM R. R. Georgetown, Del. Hand Colored
Geo. E. Swain, Druggist & Stationer

MARKET STREET LOOKING WEST FROM RAILROAD. The buildings on the right are, from the foreground, the pool hall, Theodore Burton's Garage, the Crystal Restaurant, Braunfeld's Clothing Store, and Chipman's Drug Store. Judging from the automobiles and the dirt street, this card was probably produced about 1915. Notice that the tree on the left is actually in the street bed and that the car is parked in its shade. The first speed limit in Georgetown was 12 miles per hour and all cars were required to sound their horn at each intersection. The speed limit was raised to 15 miles per hour in 1919.

RACE STREET. This picture was submitted to Rosalie Wells, secretary of the Georgetown Historical Society, for exact location. She took a long, hard look at it and said, "The cross street in the foreground is Market Street and the houses are in the block above it." She was right. A cinder block addition has been built and connected to the first house, but the rest of the houses on the right are still there.

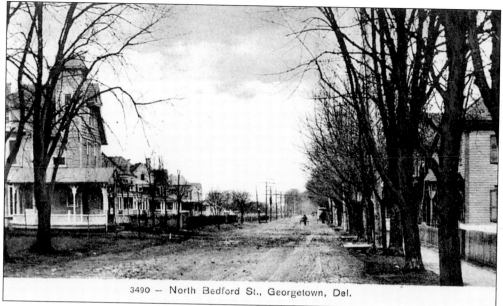

3490 — North Bedford St., Georgetown, Del.

NORTH BEDFORD STREET. This postcard shows a street light on the left, but only one. Street lights in Georgetown were extinguished at 10:30 p.m. until 1895. The street is unpaved. The Town entered into an agreement with the State to pave the streets with oyster shells at first, and then concrete. The second street to be paved was North Bedford.

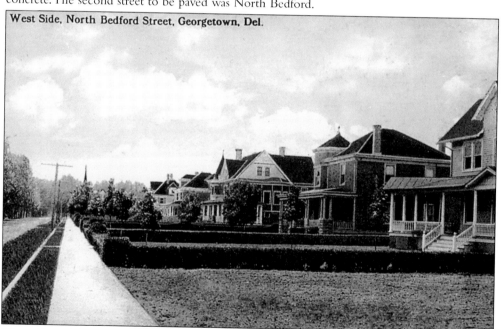

West Side, North Bedford Street, Georgetown, Del.

WEST SIDE, NORTH BEDFORD STREET. The 300 block of North Bedford Street is known as "Silk Stocking Row." All of the homes were built in the early 1900s. The middle house is a funeral home, occupied by the Parsell Funeral Home as the Dodd-Carey Chapel. The house is trimmed entirely in chestnut wood, which demonstrates the care that the original owners exercised. It also demonstrates that money was no object. Mary Street now runs west between the second and third houses.

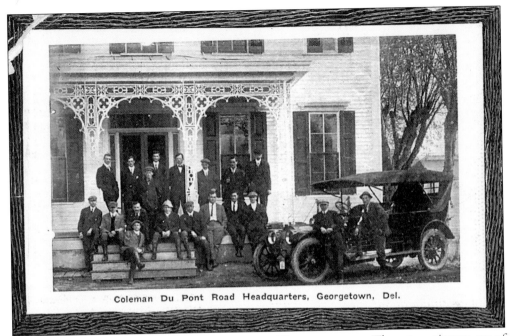

Coleman Du Pont Road Headquarters, Georgetown, Del.

COUNTRY CLUB—T. COLEMAN DUPONT ROAD HEADQUARTERS. These two pictures are of the same building. The country club occupied it first. Then, when the country club gave up the ghost, it was taken over by DuPont's road-building engineers. The house was located on South Bedford Street and apparently had so little street frontage left the one person who remembered it said that it was "pushed" down. The only information that we obtained about the country club was that Fred Whitney, a local lawyer now deceased, was a member. T. Coleman DuPont gave Delaware the funds to build the first concrete road in the state. It started at the Maryland line and was built north. The road was completed to Georgetown in May 1917. The postcard is dated 1914 and the automobile shows that this date is about right.

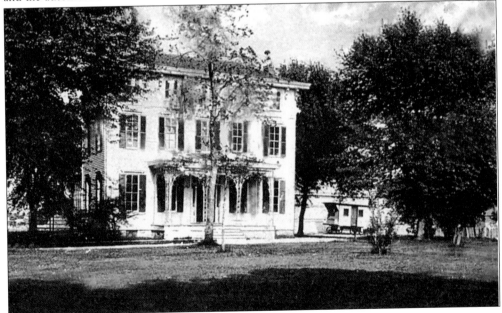

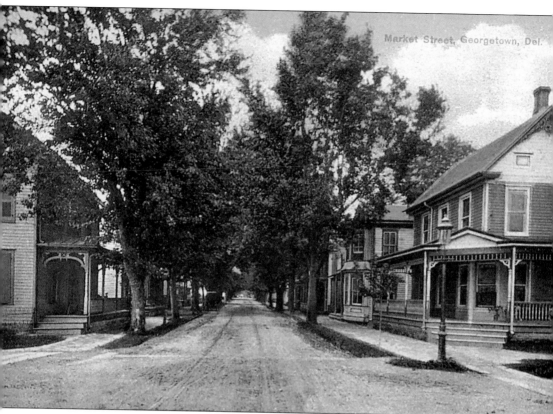

Market Street, Georgetown, Del.

MARKET STREET. We bought this card at a postcard show in York, Pennsylvania. It was clean, clear, and had been mailed on June 4, 1910. We anticipated no trouble in identifying the scene. But alas, all local sources failed, so we went to *The Sussex Countian*. That paper agreed to run the picture and two people identified it as the corner of East Market and West Streets. The street has been widened and paved and the porches and trees are gone, but the mystery has been solved.

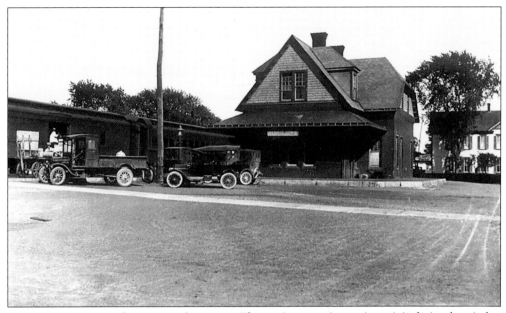

THE GEORGETOWN RAILROAD STATION. The station remains at its original site, but it has been altered several times and has only recently been restored to its earlier condition. After a fire it was rebuilt as a one story building. The railroad reached Georgetown in 1867 and the first depot was erected then. The railroad was then the Junction and Breakwater. It was taken over by the Philadelphia, Wilmington, and Baltimore in 1874. After that, the depot was increased to two stories. The Pennsylvania Railroad acquired it in 1882; after that date the depot looked like the second picture. Later, fire consumed the depot and the second floor was removed. Since then the Historic Georgetown Association has acquired the building and has rebuilt it with the second floor at a cost of approximately $650,000. It was completed in February 2003, and has reopened.

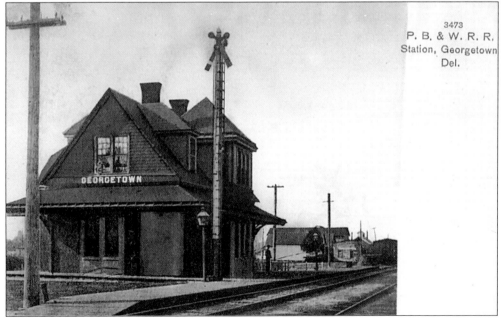

LADIES' NEW CENTURY CLUB. If you think that this is a picture of the Georgetown Library, you are right. The Ladies' New Century Club founded the library in 1899 and in 1926 moved it into a room in this building, its headquarters. Like a voracious baby, the library grew and finally took over the entire building. Over the years, the library has had plans to expand; it had a lot, but sold it. A pamphlet put out by the State Library Commission in 2001 says, "Plans are underway for a new 22,000 square foot library."

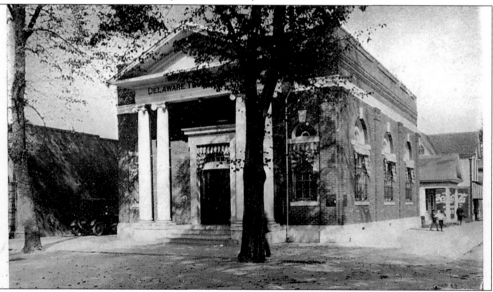

THE DELAWARE TRUST CO. In 1918 the Delaware Trust Company of Wilmington acquired the First National Bank of Georgetown and made it a branch. It then purchased property from Dr. John H. Hammond on the northeast corner of Market Street and the Circle and built a new bank building that was completed in 1919. In 1963, by a series of mergers, the Wilmington Trust Company acquired the Citizens Acceptance Corporation, which had its office in what was formerly the Brick Hotel across the circle. After extensive renovations to the hotel building, the Wilmington Trust Company moved there and deeded the Delaware Trust building to the Town as a town hall. The small building behind town hall is still there. It is the law offices of Tunnell and Raysor. The structure on the left is the former home of the Georgetown Fire Company.

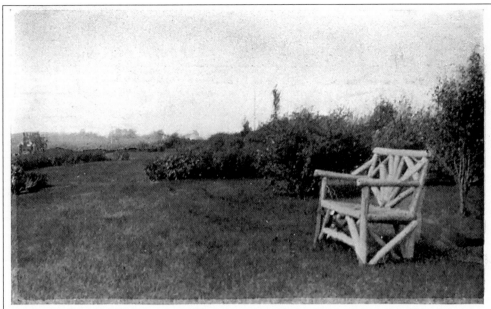

DU PONT BLVD. GARDENS, Georgetown, Del. Geo. E. Swain, Druggist & Stationer Hand Colored

DU PONT BOULEVARD GARDENS. This postcard showing a lonely bench and a single sapling behind it, planted for future shade, is of the south side of Route 9 just east of Route 113. The gardens are a memento of DuPont's generosity. The postcard also displays George E. Swain's enterprise. Swain took over the Chipman Pharmacy in 1923, dating the picture. The school buildings are noticeable in the background.

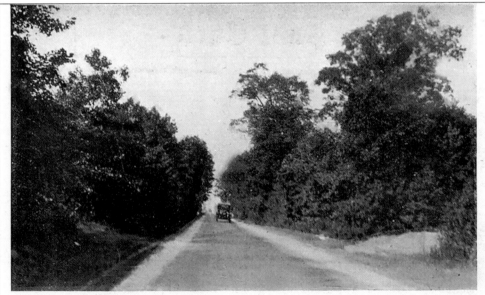

DU PONT BLVD, SOUTH OF Georgetown, Del. Geo. E. Swain, Druggist & Stationer Hand Colored

DU PONT BOULEVARD, SOUTH OF GEORGETOWN. This card was issued about 1918 by George E. Swain, the druggist. The road is two-lane with narrow dirt shoulders. The one car in sight appears to be an open five-passenger vehicle. This was before the days of color photography, so the card says "hand colored."

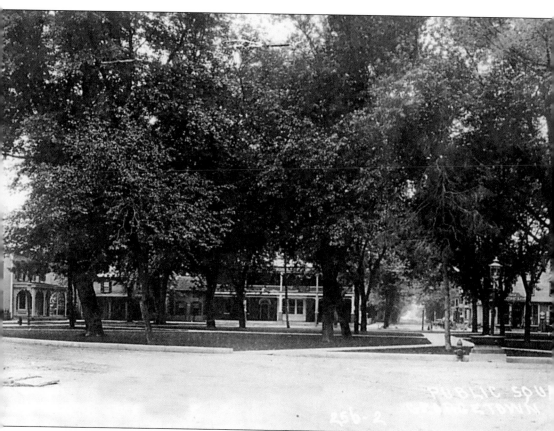

THE PUBLIC SQUARE OR CIRCLE. The public square was laid out on the original plat of Georgetown in May 1792. It was to be 100 yards each way and Market and Bedford Streets were to lead into it. Little attention was devoted to it until 1851, when the act granting self government to Georgetown passed. It provided that the town commissioners were to "prevent the exhibition of stoned horses upon the square." In 1860 Dr. William Marshall was elected to the board of commissioners and set about to beautify the square. Until then it had been used as a parking place for teams of horses and oxen; it was a catchall for rubbish and was used as a slave mart. Dr. Marshall staked off the area and had grass planted on it. He had been told that the only way he would "green the square" would be to paint it and this was his answer. The act also authorized the commissioners to "procure and set out trees," so Dr. Marshall procured elm trees and had them planted in the square. This card is postmarked in 1910 and by that time the elm trees had grown and gave shade to the square. It had been fenced in, municipal water had been installed so that the grass could be watered, and lights had been added. A tree-planting was held in the Circle on September 17, 1937, to mark the 150th anniversary of the signing of the Constitution.

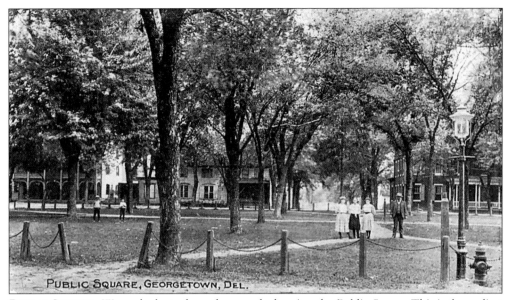

PUBLIC SQUARE, GEORGETOWN, DEL.

PUBLIC SQUARE. We are lucky to have three cards showing the Public Square. This is the earliest one. Water and electricity have come to Georgetown, but the path through the Square is unpaved. The chain fence around the perimeter is still intact, and the walkways through it are still dirt. The two posts at street edge are put in at an angle—to provide more space for walking women's skirts? But the most puzzling thing in the picture is the fact that South Bedford Street is blocked off, not for concrete paving, which came in 1920, 10 years after this card was postmarked on October 11, 1910, but perhaps for graveling. The Eagle Hotel is on the north side of the Square.

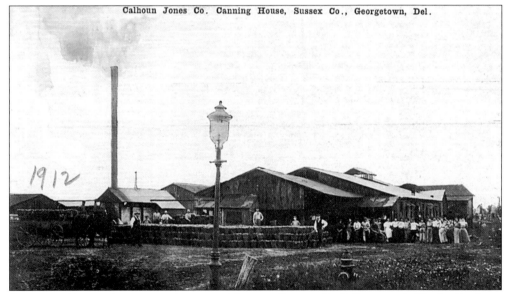

Calhoun Jones Co. Canning House, Sussex Co., Georgetown, Del.

CALHOUN JONES COMPANY CANNING HOUSE. George C. Calhoun and Charles R. Jones were partners in the cannery from 1893 to 1914. This card is dated in 1912, near the end of the partnership. The absence of a hyphen between the names fooled us into thinking we were looking for a single individual, but our friend Ronnie Dodd set us straight. The cannery was on the east side of North Race Street; it was succeeded by the J.D. Campbell Company in 1915.

Six

GEORGETOWN
SINCE 1930

Spanish is spoken here by the hundreds who have come from Latin America to work in the poultry plants. There are stores and services catering to Spanish-speaking people within the community.

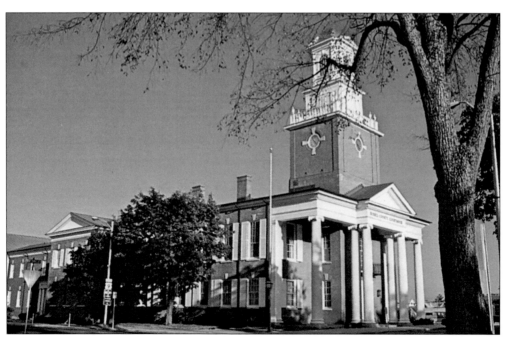

THE SUSSEX COUNTY COURTHOUSE. This is the end result of many changes and additions to the courthouse. It now extends back to Pine Street, having taken in the alley. The courthouse is now an imposing building, as well as a busy one, and is currently being remodeled.

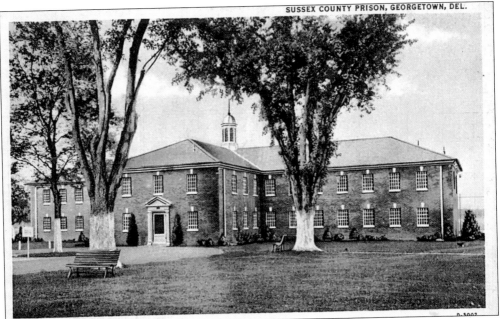

SUSSEX COUNTY PRISON. This jail was built in 1932 on what was once the Sussex County Alms House. It was later taken over by the State and the name was changed to the Sussex County Correctional Institute. In recent years the sheriff was relieved of his criminal jurisdiction. This led to a dispute with the county commissioners during which the sheriff was told to take the flashing lights off his cars.

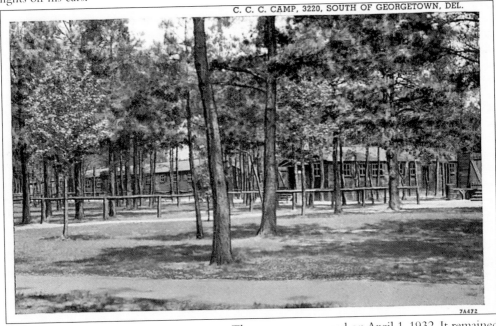

C.C.C. CAMP SOUTH OF GEORGETOWN. The camp was opened on April 1, 1932. It remained open until 1944 when it was converted into a prisoner-of-war camp. It received some notoriety in 1944 when one prisoner killed another. It was reconverted to mosquito work for a short time after World War II.

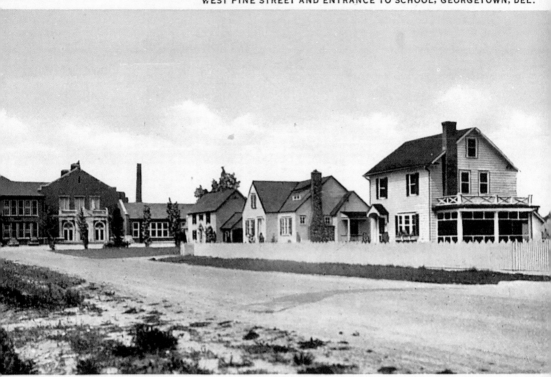

7A318

WEST PINE STREET AND ENTRANCE TO SCHOOL. West Pine Street dead ends at the high school. Pine Street is now paved and the houses shown are now occupied by the Williams on the corner, the Kinslers next, and the Malcombs in the house on the right. None of these people were living there in 1943 when the card was new. The entrance to the school is on its left side; the front faces Market Street.

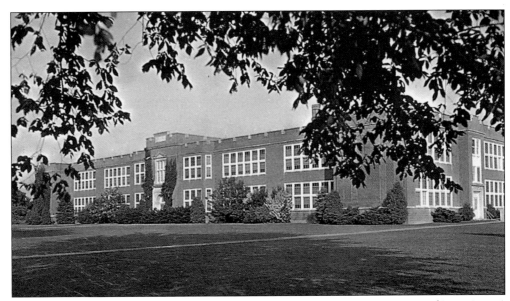

GEORGETOWN HIGH SCHOOL. This building was constructed in 1929, at a cost of $209,304.53 on West Market Street near the town limits. It was initially designed for all 12 grades but became a junior-senior high school in 1935. Thirteen elementary classrooms, an elementary library, an auditorium, and a gymnasium were added in 1935 at a cost of $367,371.77. Over the years specially equipped rooms for music, industrial arts, home economics, and sciences have been added.

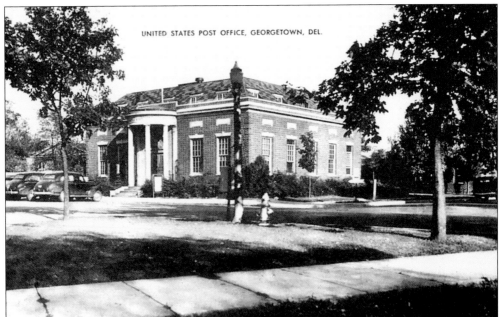

UNITED STATES POST OFFICE, GEORGETOWN, DEL.

THE POST OFFICE. The post office in Georgetown goes back to when Burton Harris was appointed postmaster and his home became the first post office. It followed the home or store of the postmaster until 1890 when the department leased the old Odd Fellows Building on the Circle. In 1932 this building was completed and dedicated with ceremony, music, and oratory. It presently houses the office of the Sussex County Council.

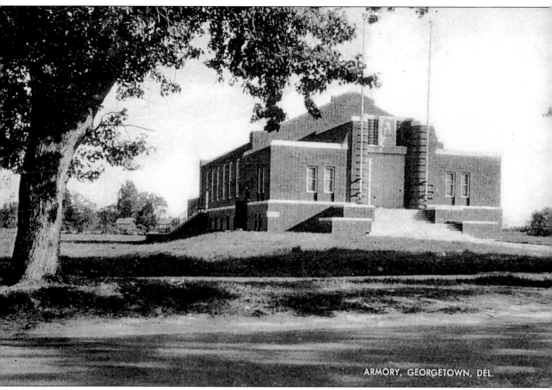

ARMORY, GEORGETOWN, DEL.

THE ARMORY. Georgetown first sought an armory in 1937 and Battery B 26th Coast Artillery was organized in January 1939. In May the governor signed a bill for $75,000 for construction. In September a location was selected on Pine Street and construction began, at a cost of $62,605. The cornerstone was laid on June 1, 1940 and the building was in use on August 8, 1940. The 26th Regiment of the National Guard was called to active duty on December 24, 1940, and the armory remained unused until 1947 when a new battery was organized.

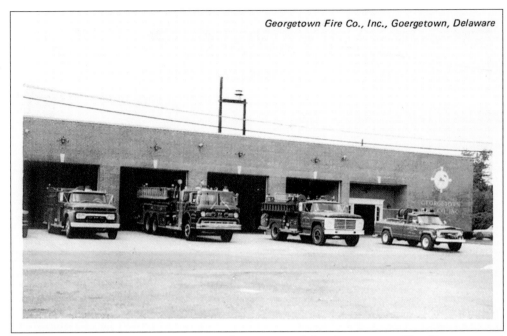

Georgetown Fire Co., Inc., Goergetown, Delaware

GEORGETOWN FIRE COMPANY, INC. This picture of the Georgetown Fire Company and equipment was submitted to a senior member of the company with the request for a date. He examined the picture carefully, looked at each piece of equipment shown, and then handed it back with a terse answer, "1961." He was referring to the equipment; the building was constructed in 1964. I thanked him and walked away, certain I had been given the right answer on the equipment.

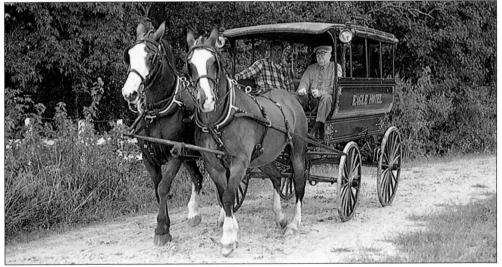

NUTTER D. MARVEL. Marvel became wealthy as the local distributor for Standard Oil. He indulged his affluence in carriages. As part of this collection, he acquired the hack from the Eagle Hotel, which had been used to collect and deliver hotel guests to and from the depot for years. His collection is now housed south of town on South Bedford Street, which is also the headquarters of the Georgetown Historical Society. Mr. Marvel is driving the hack in this picture.

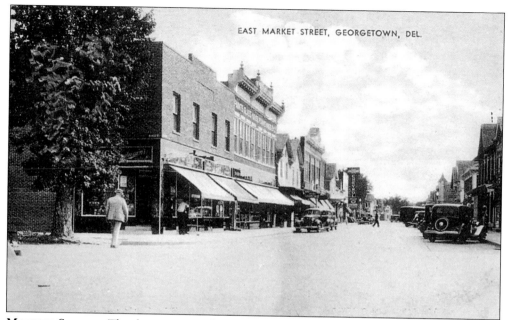

MARKET STREET. The drug store on the corner of Race Street is now the Collector's Corner Antique Shop. The next building, once a hardware store, is now the Georgetown Antique Shop. The third building now houses a barber shop, the fourth building has been demolished, and the fifth building is the home of Manlove Auto Parts. On the south side of the street are the Court of Chancery and the Department of Justice of the State. The next building has been torn down.

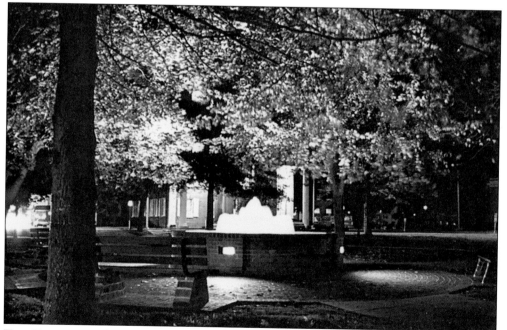

THE FOUNTAIN. The fountain in the center of the Square was the achievement of Dr. Charles Messick. It was a flawed achievement, for it always leaked. This picture shows the fountain in operation in the fall when the trees were turning. The courthouse is in the background.

Crimson Clover Fields, Georgetown, Del.

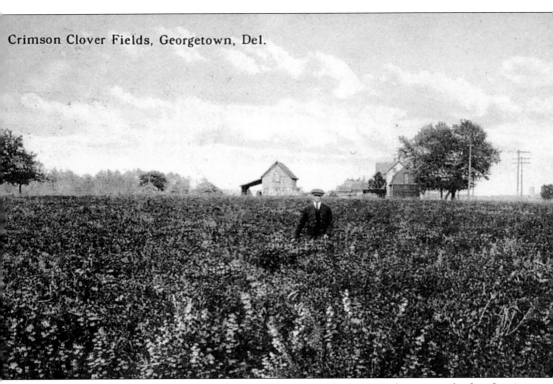

CRIMSON CLOVER FIELDS. This card is postmarked 1918, late enough for farming to have changed around Georgetown. It is a relief to find a card touting something besides corn and soybeans.

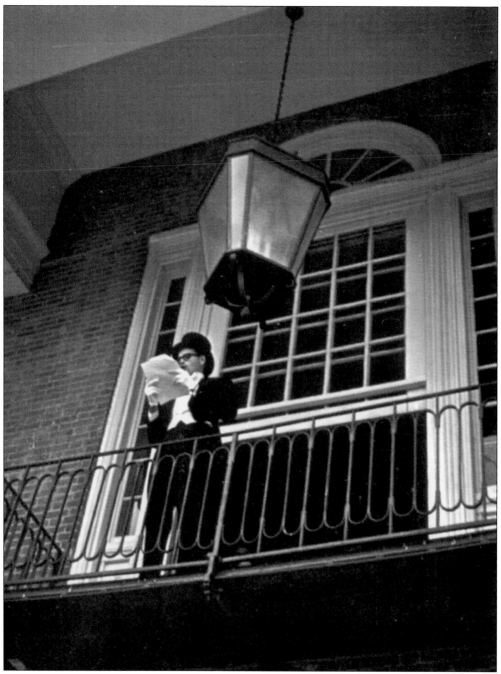

TOWN CRIER. Return Day has been a Sussex County holiday since 1828 and was established in 1840. In 1828 the law was changed to permit voting in the Hundreds and election officials had to bring their returns to Georgetown by the Thursday after the election when people congregated to see who had won. The town crier would read the complete election results from the balcony of the courthouse. It has now become a Sussex County holiday and features a parade and barbecues. This photo shows Ronnie Dodd, "The Town Crier," reading the election results. In 1976, John T. Purnell took a series of postcard pictures as an American Bicentennial event.

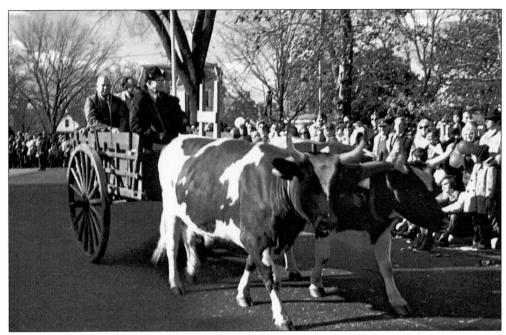

PARADE, SCENE ONE. Here is Russell Owens with his oxen in the parade.

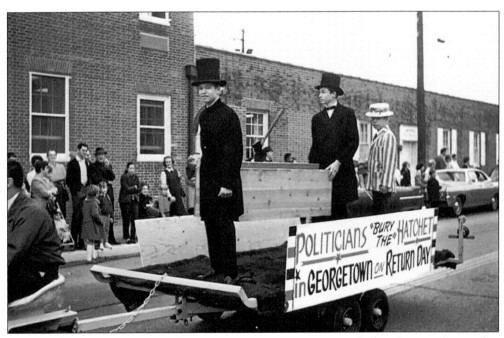

PARADE, SCENE TWO. On this float are the sons of John T. Purnell, the photographer, with a coffin in which they are burying the hatchet.

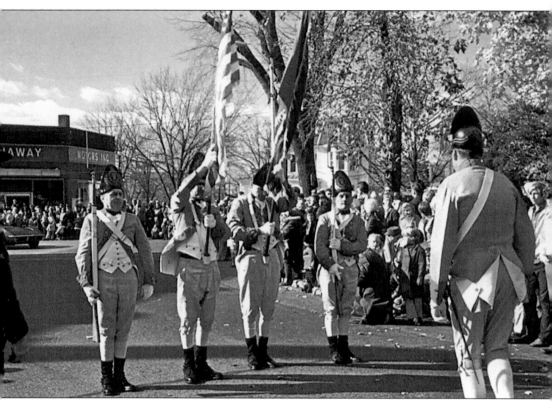

PARADE, SCENE THREE. The Delaware Blues, a military marching unit, marches in Revolutionary War costumes to enliven the crowd.

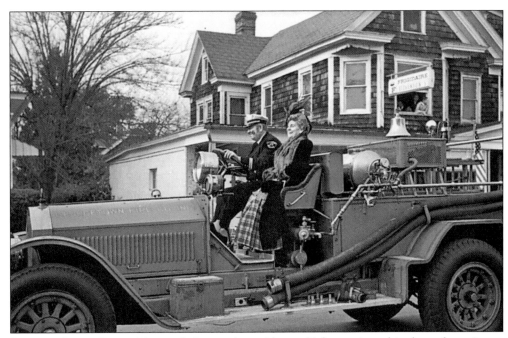

PARADE, SCENE FOUR. No parade is complete without old fire engines; this photo shows Lester Holston driving the fire engine with his passenger, Nell Barr, beside him. Note that the driver is in the right seat.

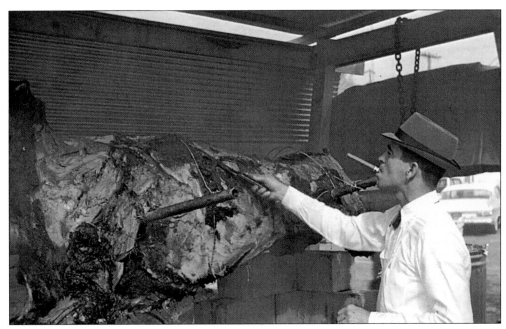

THE OX ROAST. This photo captures Ellery Parker, with cigar in his mouth, doing his job, getting ready for free food.

Seven

LAUREL BEFORE 1930

Laurel was founded in 1802 on the site of an Indian Reservation set up by the Province of Maryland at the head of navigation of Broad Creek. It was also the place where the creek could be forded. The town was the center of thousands of acres of very arable farmland and enough woodland to support the manufacture of baskets, boxes, and crates in a quantity sufficient to get all the crops to the market and to build the houses needed for a growing community. There were also enough streams that could be dammed to support dozens of water mills, both lumber and grain, to keep most of the processing local. As a result, Laurel became the business and financial center of southwestern Sussex.

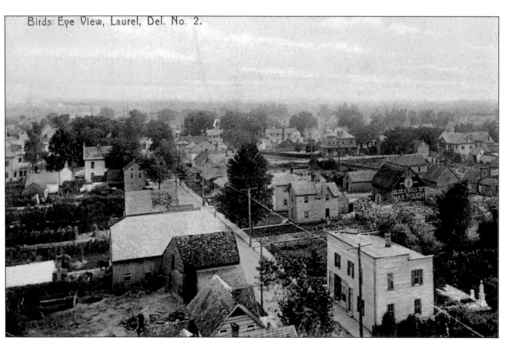

BIRD'S-EYE VIEW OF LAUREL. This postcard showing Poplar Street is postmarked 1908. Notice that a barn on the right is painted "Block Brothers Marlborough" and a tombstone behind the building on the right is the beginning of a cemetery.

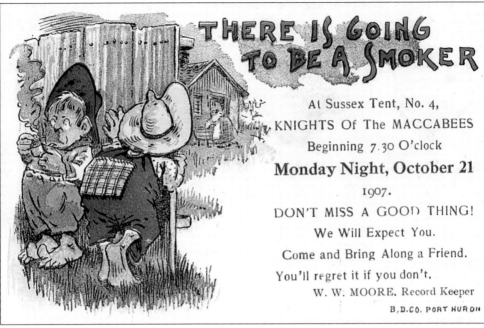

THE KNIGHTS OF THE MACCABEES. This card soliciting attendance at a smoker given by the Maccabees of Laurel strikes up no memories of anyone we have found yet. It was a life insurance lodge and still existed at Christmas time in 1925 when a brief article appeared in the *State Register*.

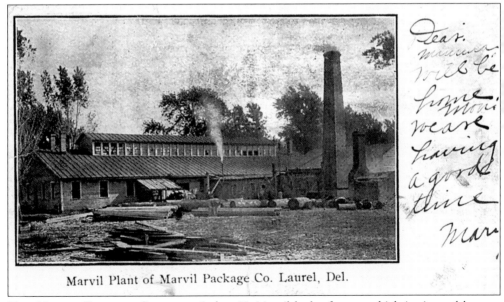

Marvil Plant of Marvil Package Co. Laurel, Del.

THE MARVIL PACKAGE COMPANY. Joshua H. Marvil had a factory, which is pictured here, at West and Townsend Streets in Laurel to make fruit baskets and crates. In 1894, when nominated as a gubernatorial candidate by the Republicans, he restarted the factory, a move the Democrats said was to secure votes. He was elected but died in office on April 8, 1895. His son, Joshua Dallas Marvil, took over the business. This card was mailed in 1905.

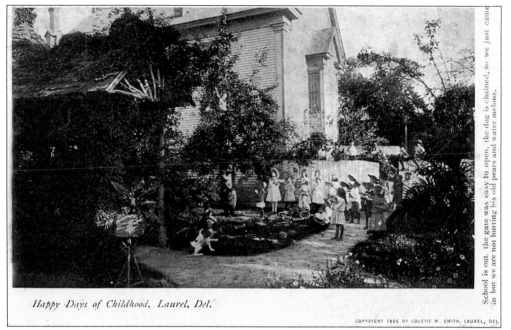

Happy Days of Childhood, Laurel, Del.

HAPPY DAYS OF CHILDHOOD. The scene pictured is near the Methodist Church. On the side of the card are the words "School is out, the gate was easy to open, the dog is chained, so we just came in, but we are not hurting his old pears and water melons." The card was copyrighted in 1905 by Loletie M. Smith, the postmistress.

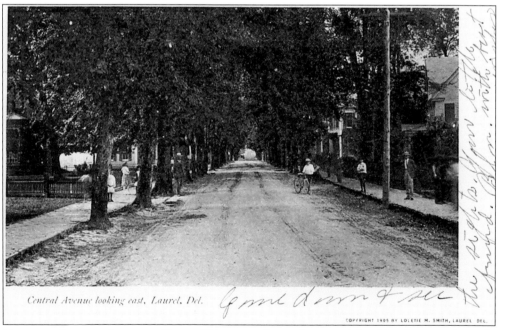

Central Avenue looking east, Laurel, Del.

CENTRAL AVENUE LOOKING EAST. This postcard was also copyrighted by the postmistress in 1905. Notice the line of trees in the unpaved street bed on both sides of Central Avenue. There is no vehicular traffic on the street, but there are a large number of children spectators and only two adults.

93

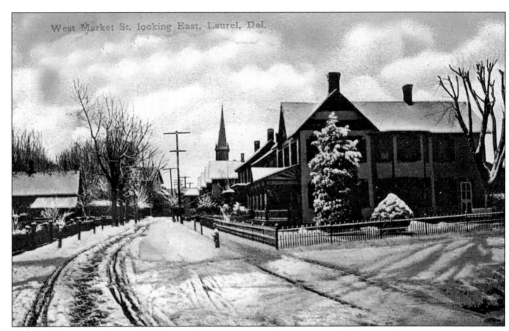

West Market St. looking East, Laurel, Del.

WEST MARKET STREET. This card is postmarked October 9, 1909, but the snow indicates the image to be from at least the previous winter. The house in the foreground belonged to a Gordy, but was later the home of the chief of police, Harley Hickman, and his family. The cast iron fence is still there. The railroad crosses Market just west of this picture. The tower is on the old Zion Methodist Church.

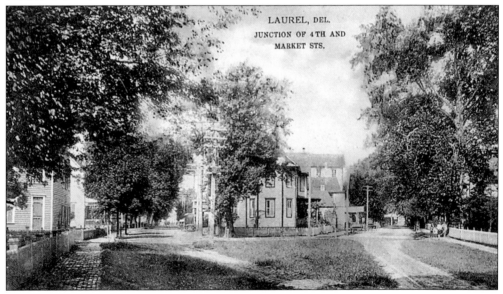

LAUREL, DEL.

JUNCTION OF 4TH AND MARKET STS.

JUNCTION OF 4TH AND MARKET STREETS. This postcard shows the intersection of Pine Street with both 4th and Market Streets. It shows a large grass plot with the brick sidewalk coming east on 4th Street as its southern boundary, Market Street on the north with a track from 4th Street coming to meet it, and a foot track also coming to meet Market. The house with three street exposures was occupied by the Bryan family. The card is postmarked in 1908; by then R.L. Francis and E.S. Leary were partners in the drug store that had this card issued.

THE WALLER THEATRE. The Waller Theatre was first built by merchant T. Jackson Waller in 1909, but it burned in 1922 and was rebuilt by him. Waller then turned his men's clothing business over to his sons, Everett and Roland, but retained the theatre. In 1936 it was remodeled, putting in new heating and seating systems. He installed a new sound system in 1937. The theatre burned again in the late 1940s. The building is now operated as a senior citizens' center.

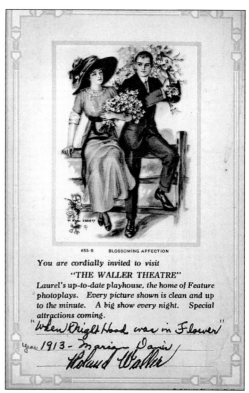

655-5 BLOSSOMING AFFECTION

You are cordially invited to visit
"THE WALLER THEATRE"
Laurel's up-to-date playhouse, the home of Feature photoplays. Every picture shown is clean and up to the minute. A big show every night. Special attractions coming.

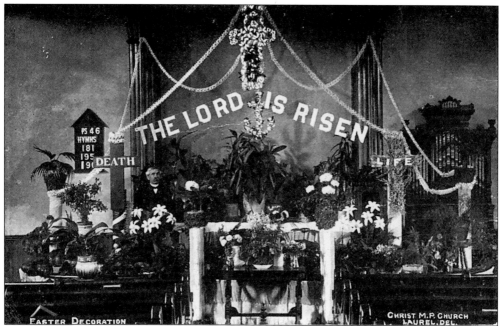

EASTER DECORATION CHRIST M.P. CHURCH
LAUREL, DEL.

EASTER DECORATION. This card is such a different Easter card that we had to include it. It is the first such card we have ever seen that shows a church interior decorated for a holiday—and so well done. It makes one want to sing, rejoice, and give praise to the Lord. It is the Christ M.P. Church.

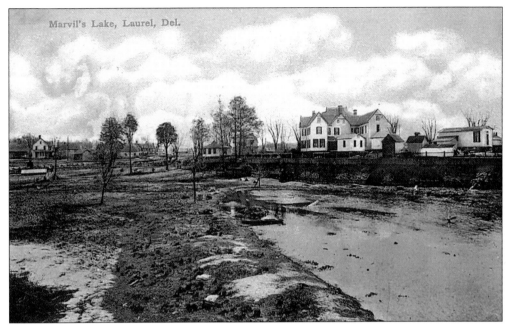

MARVIL'S LAKE. The large house pictured in the background was the Marvil home, which has since burned to the ground. The junction of Townsend and West Streets is behind the house. The Marvil lumber plant is also in the background. Logs were brought to the plant and immersed in boiling water to loosen the bark. A pipe from the plant then drained the water into the lake.

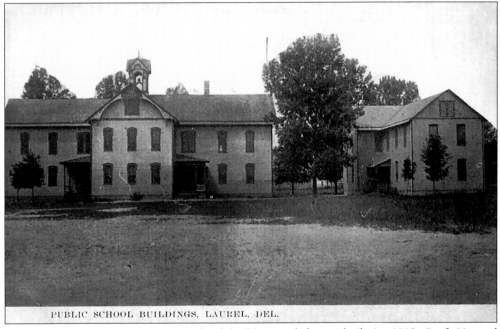

LAUREL PUBLIC SCHOOLS. The school building at left was built in 1885. Prof. Howard Slagenhour was the principal of the school, which had 7 grades, 330 pupils, and a faculty of 8. The school year was 9 months. The school building at right dates from about 1912. The high school dates to 1894.

ORLANDO WOOTTEN This picture of Orlando Wootten in a baby carriage was taken in front of his home on Sixth Street behind the Episcopal Church. When he grew up he became a reporter/photographer for *The Daily Times*. In retirement he became a noted photographer of nature and authored a book of his pictures. Many homes on Delmarva have Wootten pictures on their walls.

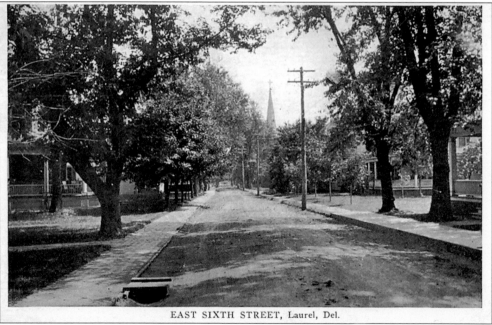

EAST SIXTH STREET, Laurel, Del.

EAST SIXTH STREET. The walkway running from the street on the north side belongs to the house on the northeast corner of Poplar Street, which is occupied by Peter Short. The next house, 105 East Sixth Street, belongs to Don Phillips, and the house on the south side, of which only the porch is visible, belongs to Keith Phillips. The spire of the Episcopal Church can be seen in the background.

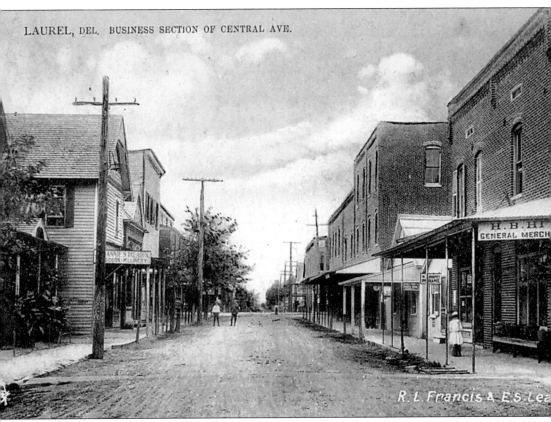

BUSINESS SECTION OF CENTRAL AVENUE This postcard is dated 1908, but the picture is earlier. Annie S. Hearn ran the millinery shop on the left, while Herbert B. Hitch ran the general merchandise store on the right. R.E. Francis and E.S. Leary, whose names appear at bottom right, ran the drug store that published the card. According to the State Register, Francis was not in business with Leary in 1905. This picture was taken on the rise from the creek. Market Street is in the background. The upholstered bench shown is one that Hitch provided for the comfort of his customers. The many uprights served not only to hold up the tin roofs, but also served as convenient hitching posts for the horses.

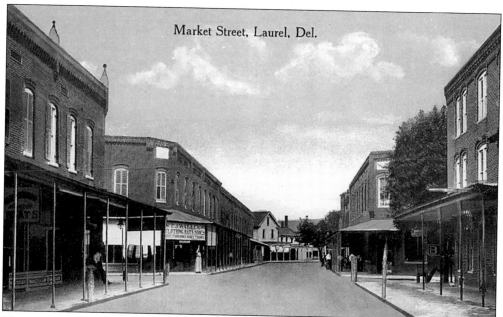

Market Street, Laurel, Del.

MARKET STREET. T.J. Waller's store is on the northeast corner of Market Street and Central Avenue and a tree was at the southwest corner. The Wilmington Trust Company is now on the northwest corner and the building on the northeast corner has been demolished. There was a grocery store on the southwest corner. At the time of this picture, city water had come to Laurel; see the fire plug on the southwest corner.

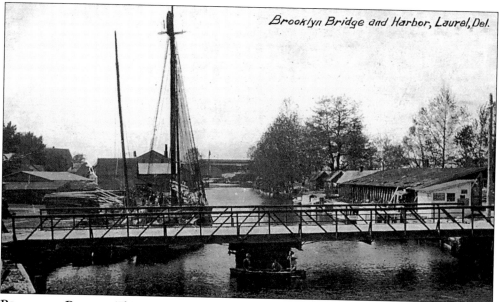

Brooklyn Bridge and Harbor, Laurel, Del.

BROOKLYN BRIDGE. This is the Delaware Avenue Bridge. It served Brooklyn when Brooklyn was not a part of Laurel because it had rejected joining it by a vote of 28 to 25. The small shop shown on the right bank of the creek was operated by Daniel Yates who sold, as told by our informant, penny candy. Marvil Package Company allegedly built this bridge for its own convenience. Their plant was located further down creek. The bridge has now been replaced by a fixed bridge.

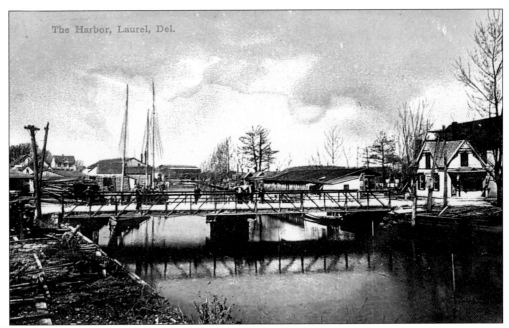

The Harbor, Laurel, Del.

THE HARBOR. This is the headwater of navigation of Broad Creek. Beyond this are dams and a series of ponds. When this picture was taken the original mill was still there and on the banks were a canning factory and a fertilizer factory.

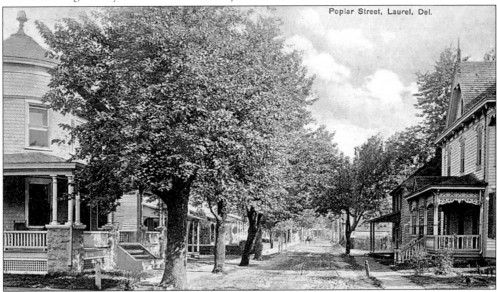

Poplar Street, Laurel, Del.

POPLAR STREET. The house in the left foreground is No. 312 and is located on the corner of Sixth Street. The stone pillars on the porch made identification easy, as well as the three wooden posts resting on the pillars. The porch spindles are still in place, but the entrance to the house has been enclosed and the acorn on the roof has disappeared. The house on the right is No. 323 and its exterior is unchanged. The Victorian scrollwork is still in place and the porch spindles and rail are intact. We have seen the side yard of this house on another card showing Sixth Street; the sidewalk running at an angle to the house identified it. The house has been made into three apartments.

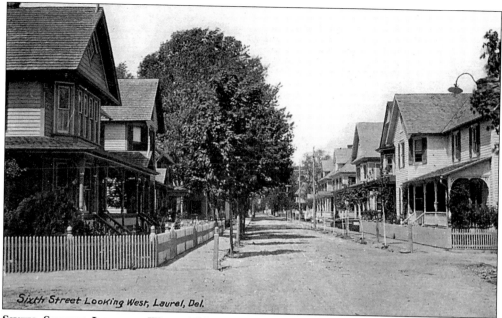

Sixth Street Looking West, Laurel, Del.

SIXTH STREET LOOKING WEST. This scene is at the corner of Spruce Street. The second floor front windows on the south side of the house at left are distinctive. It is owned by Keith Wongus. The house next to it belongs to Robert Lewis. The corner house on the north side is vacant. This card was manufactured by Eureka Post Card Manufacturing Company of Wilmington, Delaware.

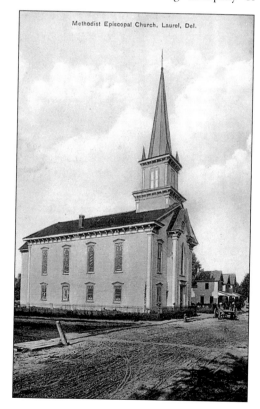

Methodist Episcopal Church, Laurel, Del.

METHODIST EPISCOPAL CHURCH. The Centenary United Methodist Church of Laurel was founded in 1802 as a result of a widespread religious revival and was called Zion Meeting House. This church was built on the present site and was a plain structure 36 feet by 40 feet. There were no lights, and heat was provided by pine knots in sconces. By 1833 the congregation had outgrown the church. It was given to the black community and moved and a new one was built on the site. The fourth church, built in 1911–1912 was named Centenary to honor the new incoming century. The postcard picture, which shows the third church, also depicts a fireplug in the edge of the pavement in the street, showing that public water and sewer lines were in place in Laurel, but that street paving had not yet arrived by 1911.

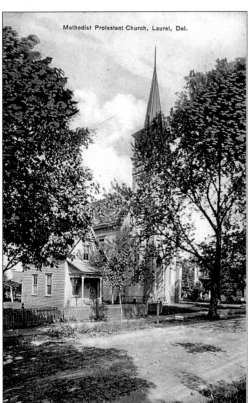

Methodist Protestant Church, Laurel, Del.

THE CHRIST METHODIST PROTESTANT CHURCH. This card was published by H.L. Francis and T.L. Brimer and is postmarked 1912. The Christ Methodist Protestant Church was built in 1867. The small house alongside it could have been the parsonage or church offices. A picket fence surrounds it on all sides.

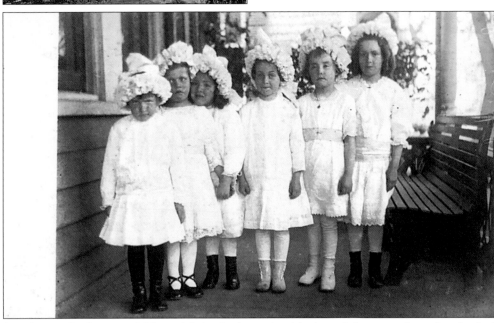

SIX GIRLS OF LAUREL. This card is intriguing—six girls dressed for a part in a church play? Only three are known: third from the left is identified on the back as Mary Catherine Collins of Laurel, next to her is Elizabeth Sirman, and next is Eleanor Barnett. Their hats are peaked and flowered. All the dresses were white, but the styles were different.

ROSEMONT. The most historic house in Laurel is probably Rosemont. Located at 121 Delaware Avenue, it was built in 1763 by James Mitchell whose son, Nathaniel Mitchell, was Delaware's sixth governor. This two-story and attic, clapboard, and shingle house had been the home of the Elliott-Collins family for generations when this picture was taken. J.M. Collins and his daughter, Mary Catherine, aged four, are in front of their home, which is sporting its winter storm door. The property is now owned by Kathleen Tissian.

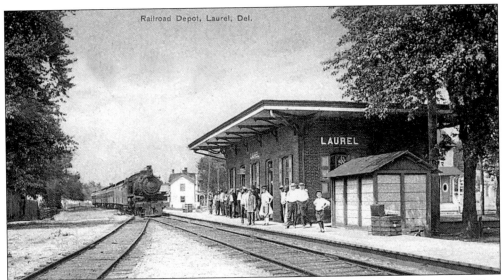

Railroad Depot, Laurel, Del.

RAILROAD DEPOT. The Delaware Railroad reached Laurel in 1859 and a jubilee was held to celebrate the occasion. A small steamer that Laurel citizens chartered would pick up freight on Broad Creek and the Nanticoke for shipment north by rail. Passenger service on the railroad continued for over 100 years. One of the authors and his nephew took a bus to Wilmington and caught the train for its last passenger run south to Delmar. This card was mailed in 1909, when passenger service was at its height.

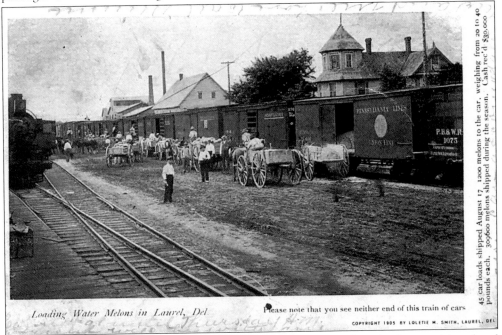

Loading Water Melons in Laurel, Del.

Please note that you see neither end of this train of cars

45 car loads shipped August 17, 1200 melons to the car, weighing from 20 to 40 pounds each. 30,600 melons shipped during the season. Cash rec'd $30,000

COPYRIGHT 1905 BY LOLETIE M. SMITH, LAUREL, DEL

LOADING WATERMELONS IN LAUREL. On August 17, 1905, 45 rail-car loads were shipped and 30,600 melons were shipped during the season—this was no extraordinary event. During the first four days of the 1925 season, 78 railcars plus 16 cars of cantaloupes were dispatched. Laurel is the center of a superb agricultural area. While buyers no longer ship by rail, the quantity that is shipped by truck is still astronomical. This is another postmistress-copyrighted card.

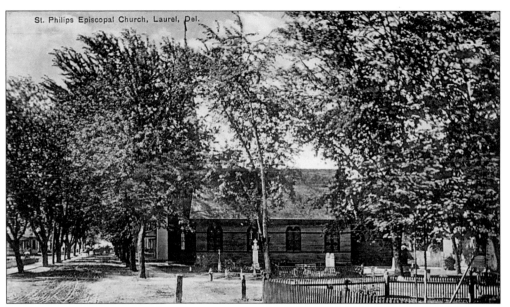

St. Philips Episcopal Church, Laurel, Del.

SAINT PHILIP'S EPISCOPAL CHURCH. Episcopal services were held in Laurel in 1831, but the church was not built until 1847 and it was not consecrated until May 22, 1850. A new church was begun at Sixth and Central Streets in 1874; this picture shows that it was of wood. It was brick veneered in 1924 and re-dedicated on November 8, 1925. A new organ was installed in December 1881, and a new brick parish house was added to the rear of the building in 1937.

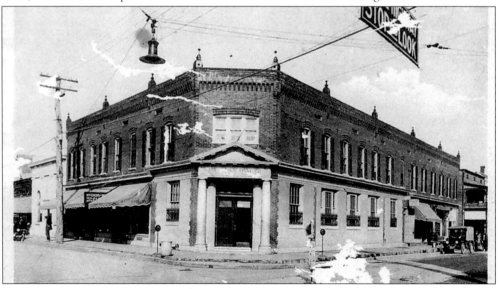

THE SUSSEX TRUST COMPANY. This building was erected by Thomas C. Horsey. In addition to the bank, Hitchens and Phillips Men's Store and Mitchell's Restaurant are on Market Street to the left. A restaurant and soda shop were located on Central Avenue to the right. The Sussex Trust Company was organized as the Sussex Trust, Title, and Safe Deposit Company in 1898 and opened for business in its own building on January 2, 1899. That building was on the west side of Central Avenue below Market Street. Daniel J. Fooks was president and John H. Elliott cashier. This card was made about 1917. By that time the Trust Company had leased most of the Horsey building and had put the entrance on the corner.

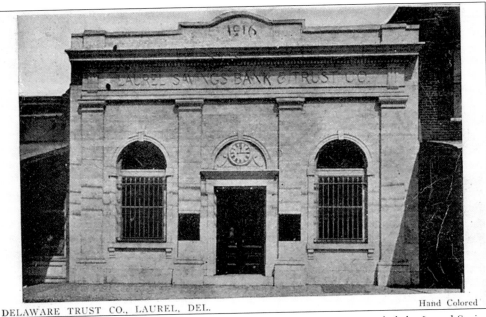

DELAWARE TRUST CO., LAUREL, DEL. Hand Colored

THE DELAWARE TRUST COMPANY. The Delaware Trust Company succeeded the Laurel Saving Bank and Trust Company that built this building. The building is located on Market Street several doors west of Sussex Trust. The Delaware Trust Company was a Wilmington bank, and in April 1925, was taken over by the Sussex Trust Company, which vacated the building. It was taken over by James Windsor as a meat and grocery store.

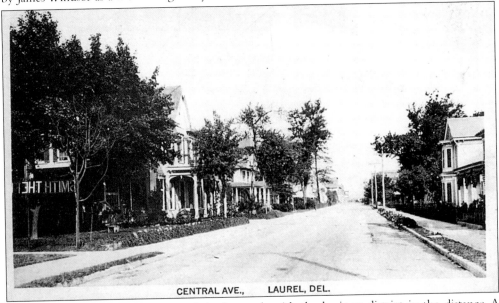

CENTRAL AVE., LAUREL, DEL.

CENTRAL AVENUE. This photograph looks north with the business district in the distance. A two-lane strip in the center is paved but the parking area is unpaved; curb, gutter, and sidewalks are in place. The sign of Smith the Florist is at left. Succeeding her business in later years were a funeral parlor and antiques shop. In 1937, a 1913 town ordinance was revived requiring each male resident of Laurel between the ages of 21 and 65 to work one day a year on the streets or to pay $1 in lieu thereof. Preachers and teachers were excepted. And no free liniment.

Eight

LAUREL SINCE 1930

The establishment of a major shopping center east of town on U.S. Route 13 came at the turn of the 21st century. The additional dollars spent and homes bought in the community more than made up for a few vacant stores. Since 1930, the collections in the churches are larger—and there are more churches.

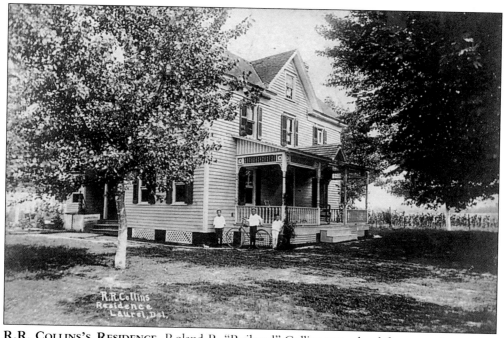

R.R. COLLINS'S RESIDENCE. Roland R. "Railroad" Collins was a local farmer and carpenter, known for building the steeple on Mount Pleasant Church. Until recently, his home was still standing on the south side of Sharptown Road, two miles southwest of Laurel.

SUSSEX TRUST COMPANY. Banks have not gone bankrupt since the days of Franklin Roosevelt; they now merge with stronger banks. When the Sussex Trust rebuilt its building, it became a target for a merger and merged with Wilmington Trust Company. The Sussex Trust Company was organized in January 1889 at Laurel. By 1905 it had three branches. It acquired the Delaware Trust Company in 1925. In 1933, when President Roosevelt closed the banks, the Sussex Trust was allowed to reopen in a week. Its present building, built in 1933, was a sign of its strength.

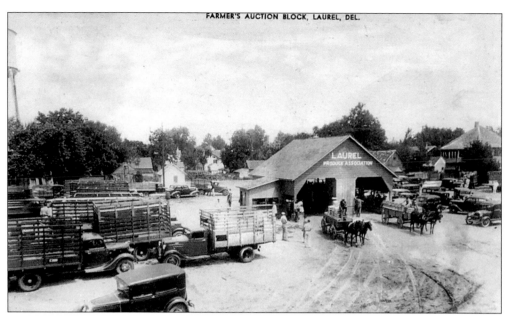

FARMER'S AUCTION BLOCK. This postcard, dated 1960, shows the grounds of the Laurel Produce Association next to the railroad to the south of town. Two wagonloads of produce have just emerged from the block. The empty trucks are waiting for loads. The auction block is now located on the highway north of town. Since 90 percent of the produce that goes through the block is transported by truck, a location on the railroad is no longer necessary.

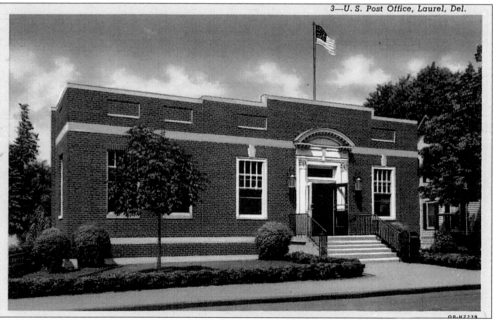

3—U. S. Post Office, Laurel, Del.

THE OLD POST OFFICE. The old post office was located at 400 South Central Avenue. It was more expensive than planned and $5,000 had to be added to the $45,500 that had been allowed for it. The post office opened on December 1, 1935, in time for the Christmas rush. This building has been sold to a firm of accountants. The old, old post office was located on Market Street. The new post office opened on June 18, 2001.

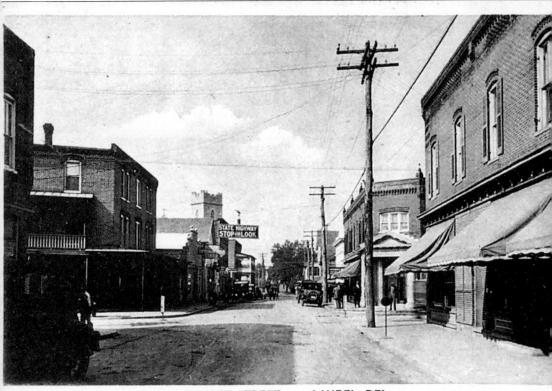

MARKET STREET, LAUREL, DEL.

MARKET STREET. The second floor porch on the left belonged to the Laurel House Hotel. The street sign says "State Highway, Stop and Look." The stone tower of Centenary Methodist Church looms in the background and indicates a date for this card no earlier than 1914. T.J. Waller's menswear store was on the right-hand corner of Central Avenue, with the Sussex Trust on the left. On December 11, 1925, it was reported in the Laurel State Register that new traffic signals were installed at Market and Central Streets; the new signals were red for stop, blue to go straight ahead or make a right turn, and yellow for a left turn. Laurel rejoined the conventional system of lighting in 1936 at a cost of $1,200.

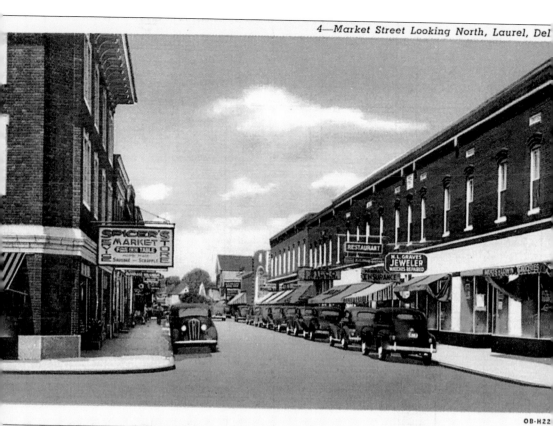

OB-H22

MARKET STREET LOOKING NORTH (ACTUALLY WEST). The Laurel Redevelopment Corporation was formed to stop the deterioration of downtown Laurel. Land on both sides of the creek as well as the stores on Market Street east of Central Avenue were becoming un-tenantable. Johnny Janosik, for example, started business on East Market but moved his business to U. S. Route 13. So Laurel businessmen banded together, formed their own corporation, raised their own capital, and with it bought up the deteriorated properties and razed them. They created a park, built a new line of stores, promoted a restaurant, and stopped further deterioration. Spicer's Market is no longer there, but there are other tenants in the Globe Building.

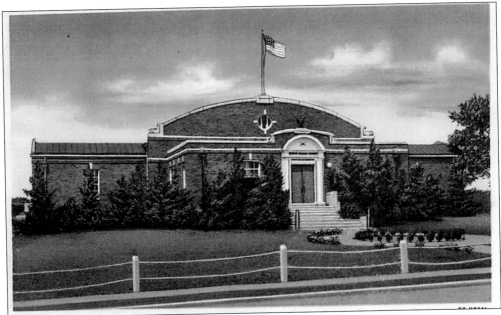

THE ARMORY. Battery A of the 261st Coast Artillery Battalion was organized in 1924 and was installed under the command of Capt. William Torbert, but it had no home. In 1927, the armory was built at a cost of $50,000, excluding the land. The site selected was on North Central Avenue, north of the bridge. It was owned by John Collins who enlarged the lot and knocked off $150 from the purchase price, leaving only $1,350 to be funded by other donations, which were easily raised. In 1930 an addition costing $10,000 was erected.

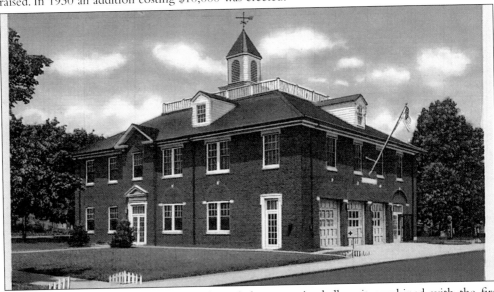

MUNICIPAL BUILDING. In 1936 Laurel needed a new city hall so it combined with the fire company, bought land from the railroad on Poplar Street, and built a common building with the fire company on the first floor and city hall on the second. A referendum approved the $20,000 cost of the building 28 to 1 and it was erected. This joint occupancy worked until 1977 when the fire company moved into new quarters on Tenth Street and the City took over the whole building except for Alderman's Court #35.

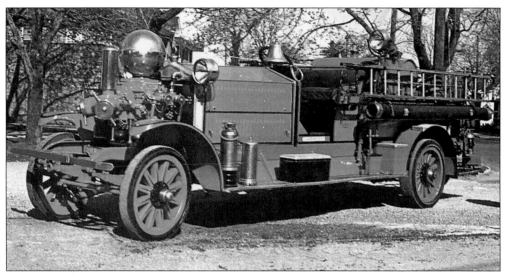

LAUREL VOLUNTEER FIRE COMPANY. The Laurel Volunteer Fire Company was founded in 1899 at the instigation of the town council following the big fire of that year. It was originally called the Hose Company and 25 men signed up and elected Isaac J. Wootten fire chief. In 1905 a contract was let for a Firemen's Room at city hall. This was the first mention of a separate space for the fire company. In 1925 the fire company had two engines. In 1936 the Town purchased land for the present city hall and the fire company got the first floor. By 1977 the fire company had outgrown its quarters in city hall and moved into the present quarters on Tenth Street where there is also plenty of room to house civic events. This 1924 Ahrens Fox 1,000gpm pumper has now been retired from active duty.

FIRE DEPARTMENT AMBULANCE. A Lion's Club was organized in Laurel in December of 1935. Probably as their first project, the club raised the money to buy the first ambulance for the fire company in March of 1936. In November of 1937 a festival was held by the Lions to buy a second one. By 1997, the fire department organized its own money-raising ambulance service and had its own successful drive for the one shown on the above postcard.

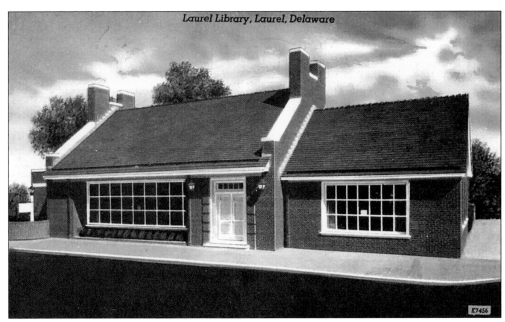

Laurel Library, Laurel, Delaware

K7456

LAUREL LIBRARY. The Laurel Library was founded in 1909 by the New Century Club. They maintained it in rooms in the Masonic Hall until 1924 when it moved to the Community House. In 1932, the New Century Club relinquished direction to the Delaware State Library Commission. The present building on East Fourth Street was built as a memorial to Mary Wootten Carpenter by her husband, Walter Samuel Carpenter, and her three sons, John, Samuel, and Edward. Mary Carpenter was a Laurel native.

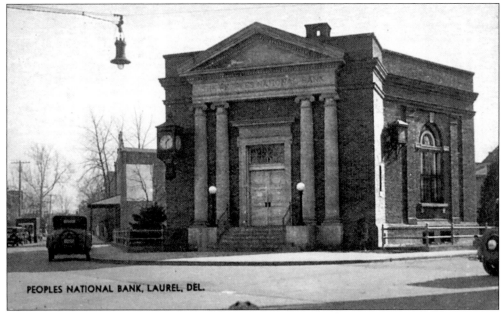

PEOPLES NATIONAL BANK, LAUREL, DEL.

PEOPLE'S NATIONAL BANK. The People's National Bank was founded in 1903 and built this building in 1926. It was in succession a branch of the Farmers Bank, the Girard Bank, the Mellon Bank, and, since 1997, the Bank of Delmar (now Delmarva.) The building behind the bank has been razed for bank parking.

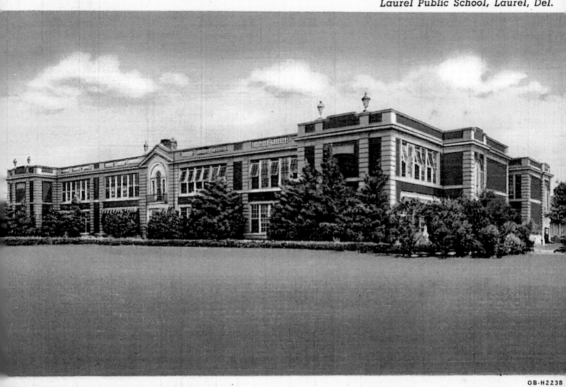

OB-H2238

LAUREL PUBLIC SCHOOL. This building was constructed as the new combined school, excluding blacks, in 1921. The subsequent decision of the Supreme Court outlawing segregation changed things for Laurel. This is now the junior high school; a new high school was built in 1973. The former African-American school has become an elementary school and a new elementary school has been built in North Laurel.

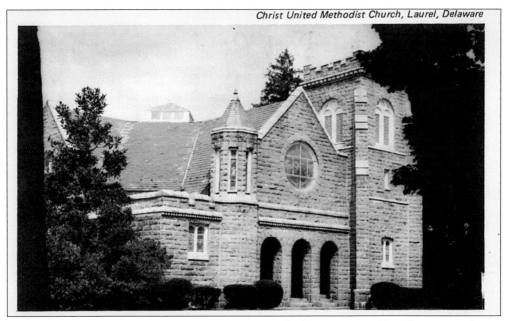

CHRIST UNITED METHODIST CHURCH. A new Methodist Protestant Church was started west of the railroad on West Street in 1832 and remained there until 1867. A new church was built on Central Avenue in that year. A parsonage was built on the corner of Sixth and Central Streets in 1884. With unification, the church became Christ United Methodist.

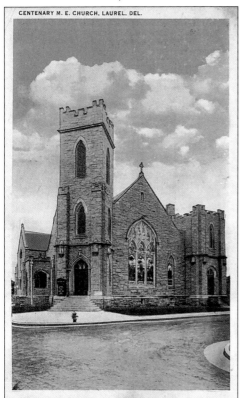

CENTENARY M. E. CHURCH, LAUREL, DEL.

CENTENARY METHODIST CHURCH. In 1802 Zion Meeting House was erected on the southwest corner of Back and Corn Streets; this was the beginning of the Centenary Methodist Church. In 1833 the old church was given away and a new church, called New Zion, was built on the lot. By 1866 this church had become too small and it was similarly given away and a third building was constructed. In 1911–1912 the present granite church was built on the same lot and is still in use. The new educational and recreational building was added in 1951.

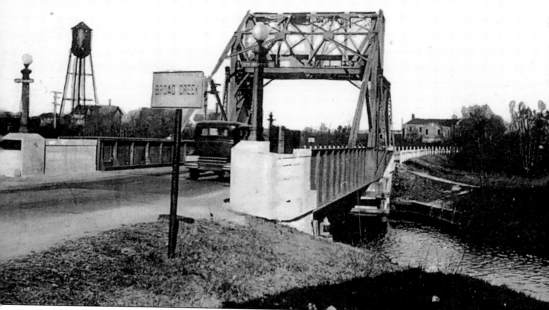

LAUREL RIVER BRIDGE. This is one case where the Laurel Chamber of Commerce did not get together with the State Roads Commission. The sign says Broad Creek, not Laurel River. The picture is of the stream through Laurel looking north. The water tower in the background has been replaced by one having twice the capacity. The Insurance Market building, where one co-author works, had not yet been built. The plaque on the left side of the bridge by the walkway says that the bridge is a Scherrer Rolling Lift Bridge, patented in 1898, and that the bridge was built in 1923 by Al S. Fox.

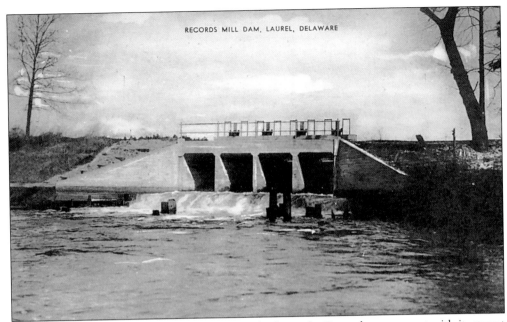

RECORDS' MILL DAM. When the mill dam washed out, the Records name went with it, except on this card. The dam was rebuilt by the state and is called the Laurel Dam.

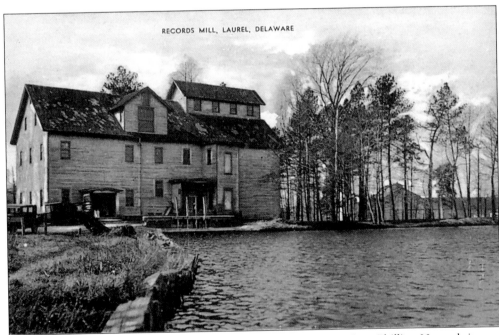

RECORDS' MILL. The last operator of the Records' Mill was Harrison Phillips. He took it over from the Abbots, who were into poultry, about 1940. The mill building was destroyed by arson.

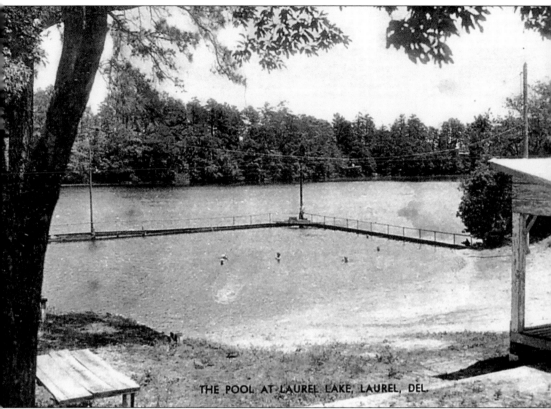

THE POOL AT LAUREL LAKE, LAUREL, DEL.

THE POOL AT LAUREL LAKE. The fenced-in area of Laurel Lake was the municipal swimming pool. It was created about 1920. The "pool" had a lifeguard and a system of long planks to hold the fence. It lasted until the planks rotted away.

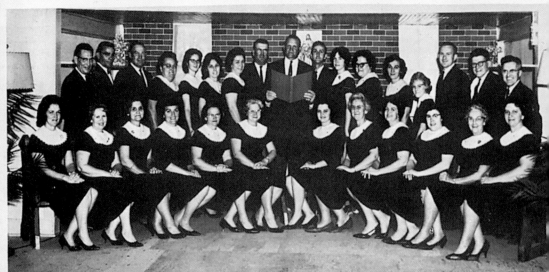

HYMNS OF THE OLD COUNTRY CHURCH

WSUX 1280 1:30 SUND.

EASTERN SHORE GOSPEL CHOIR LAUREL, DELAW.

O COME, let us sing unto the Lord: Ps 95:1a

EASTERN SHORE GOSPEL CHOIR. The Eastern Shore Gospel Choir got its start at Delmarva Campground. Shown in this 1964 photo, from left to right, are (front row) Ann Whaley, Florence Callaway, Margaret Boyce, Shelby Johnson, Elsie Boyce, Anna Whaley, Ann Boyce, Wilma Dorman, Arlene Betts, Beverly Hudson, Elizabeth Brittingham, and Betty Ralph; (back row) Jack Hudson, Lester Williams, Wilfred Whaley, Lula Williams, Linda Mutchler, Barbara Williams, Eliza Pailer, Manning Boyce, Isaac Mitchell, Shotty Johnson, Joyce Mutchler, Charlene Dukes, Marie Derrickson, Leslie Hopson, David Boyce, Matt Records, and Arthur Williams. The choir traveled in Mrs. Derrickson's school bus. A member of the group offered a prayer before the bus took off on each trip and on many occasions late-comers arrived during the prayer, so that it became the saying in the group that they were "saved by the prayer."

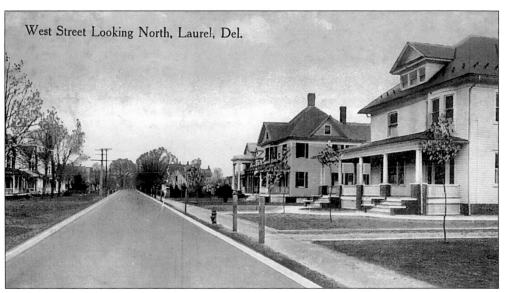

West Street Looking North, Laurel, Del.

WEST STREET LOOKING NORTH. The two houses in the foreground were new in 1914, the date on the card. The third house with the pillars is the noteworthy one—it is the Harry Fooks house. Fooks was a wealthy canner who operated the cannery at Central Avenue and Broad Creek.

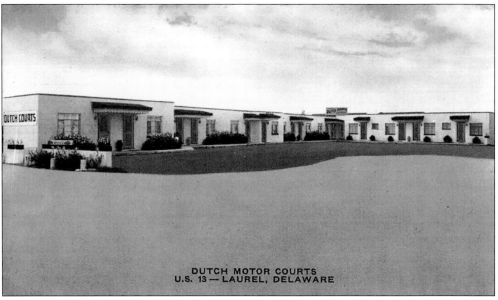

DUTCH MOTOR COURTS
U.S. 13 — LAUREL, DELAWARE

DUTCH MOTOR COURTS. Dutch Motor Courts were built in the late 1940s by Ed Northam, but Mr. and Mrs. E.J. Cannon acquired them a few years later. Originally there were motor courts and a restaurant, but when the by-pass was built around Laurel, the motor courts were superfluous. Only the excellent food served by the restaurant enabled the business to survive. The motor courts were torn down and forgotten.

GOVERNOR CARVEL AND FAMILY. Gov. Elbert N. Carvel was the last of five governors from Laurel. This was one of his campaign cards. Seated, from left to right, are (front row) Elizabeth Carvel Palmer and Charles L. Palmer; (back row) Barbara Jean Carvel, Anne Valliant Carvel grandchildren Lisa and Drew Palmer, Elbert N. Carvel, and Ann Hall Carvel. A card from a gubernatorial candidate a few days before the election is an effective reminder to the members of one's party to go to the polls and vote.

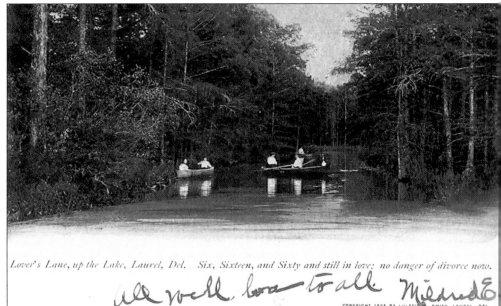

Lover's Lane, up the Lake, Laurel, Del. Six, Sixteen, and Sixty and still in love; no danger of divorce now.

LOVER'S LANE UP THE LAKE. This is an area of Record's Pond that in 1905 was completely surrounded by trees. The auto of the time was not made for love, nor was a buggy with a horse to contend with.

Nine

PONDS, THE CAMPGROUND, AND OLD CHRIST CHURCH

This chapter is divided into three parts: ponds, the Laurel and Bethel Campground, and Old Christ Episcopal Church. It begins with the ponds. The water ran into ditches, the drainage ditches ran into rills, the rills became streams, and the streams ran into ponds. The ponds were widened, deepened, and dammed. Then, someone put a mill or two on the dams and they turned out lumber or flour. When the mills stopped producing, the State of Delaware stepped in and put the ponds to recreational use.

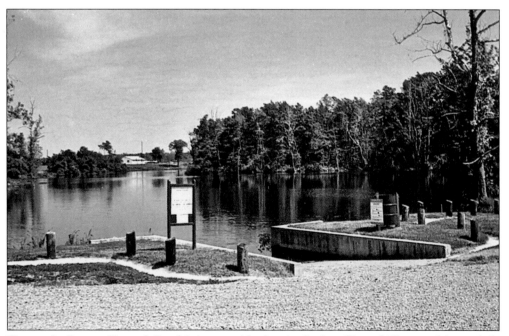

HORSEY'S POND. Horsey's Pond is just outside the city limits of Laurel. The pond is regularly stocked by the Delaware Fish and Game Commission with bass and pickerel.

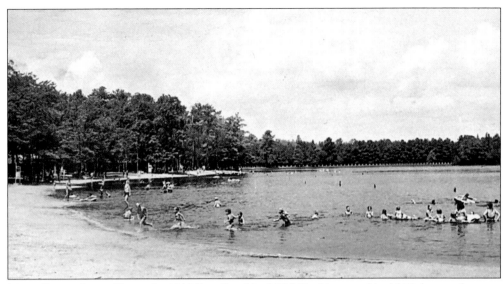

TRAP POND STATE PARK. In 1946 Trap Pond had 52,000 visitors and in 1947 the number rose above that. An agreement was made with the Delaware Game and Fish Commission to set aside a portion of the park as a game refuge. Since then Trap Pond Park has continued to break records for its use. It contains over 2,500 acres and is on Route 24, six miles east of Laurel.

A COVE IN THE CYPRESS SWAMP. This postcard could be from anywhere in the Cypress Swamp. It is typical of the area. The land is owned by Delaware Wild Lands, Incorporated.

124

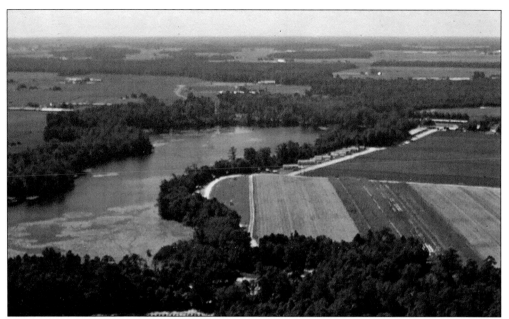

LOWE'S RECREATION AREA. This recreation area is on the shores of Chipman Pond. A magnifying glass is needed to see the trailers lined up on the pond side of the roadway shown. This is now a State-owned recreation area.

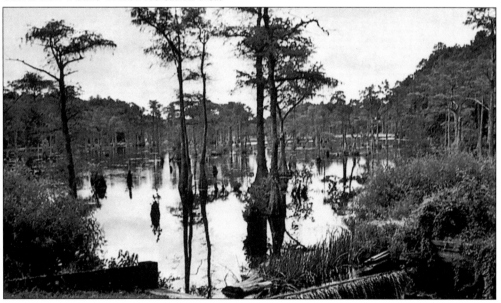

TRUSSUM POND. This pond was originally owned and operated by Benjamin Wootten who built the mill and dam before the Revolution. He died and his widow married a man named Tresham who became the miller. It is the corruption of his name that became attached to the pond. Trussum Pond is the northernmost body of water where big cypress trees can be found growing naturally. One such tree is a bald cypress more than 200 years old and 127 feet tall. The dam on the pond washed out in the storm of August 1933, and the dam was replaced by a wooden spillway built by the State the following year. This pond is located about three miles southeast of Laurel.

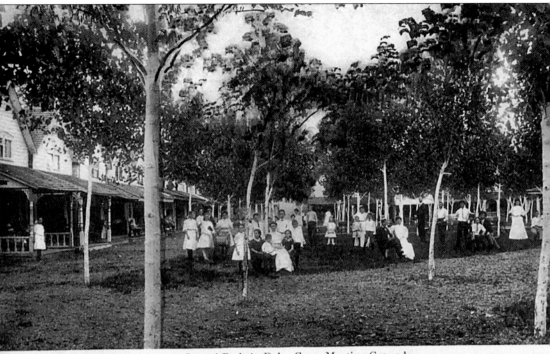

Laurel-Bethel, Del., Camp-Meeting-Ground.

THE LAUREL–BETHEL CAMPGROUND. The Laurel-Bethel Campground was incorporated in 1905 with a capital stock of $100,000. It was run as a church affiliated business. The cottages were separately owned; the lots were sold and the purchasers built their own buildings on them. "Privileges" were sold each year. The food concession was the most important one—it sold for about $6,000 in 1905. The meals cost $5 per week, $1 per day, or 50¢ per meal. Other privileges sold were the confectionery, the horse pound, the barbershop, and the photography rights. The preaching schedule was arranged separately and was designed to convert sinners or strengthen the ties to an individual's church. The owners of the cottages moved their families to the camp and stayed there for the two weeks the camp was open. This picture shows people of the camp and was probably taken on a weekday morning about 1905. Gradually the appeal of the camp waned for both cottagers and visitors, and the camp closed.

The people who were occupying the buildings at the time when the mortgage foreclosed in 1992 bought the camp. It is now a cooperative housing corporation of full-time residents. All of the existing cottages except four are owned by their occupants, who are also the stockholders of the corporation. The rest of the land is owned by the corporation and used in common. The tenant-stockholders elect their own officers to run the camp. The temporary nature of the camp has been changed—plumbing and heating have been installed—but the closeness of living is unchanged. To obtain the right to gain admission, a prospect must submit three letters of recommendation from non-family sources and must be examined and approved by the board of directors. Only then may the previous owner transfer his cottage and stock to the applicant. The campground is a short distance north of the end of Route 9 at Route 13.

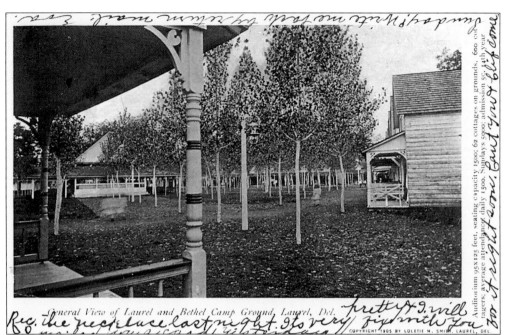

General View of Laurel and Bethel Camp Ground, Laurel, Del.

GENERAL VIEW OF THE CAMP. This view of the camp shows the auditorium in the center. The promenade can be seen around it, with the cottages facing the promenade. Many a marriage has begun on the promenade; many young people used it as the place to put their best foot forward. The auditorium seated 1,500. Daily attendance was about 1,500 and on Sundays 5,000. The camp meeting was organized in 1888 and lasted until 1992. While religious services were going on, conversations were conducted in a whisper. North and southbound trains made a special stop at the campground. Meals were served at the hotel or a basket lunch was available to be eaten anywhere.

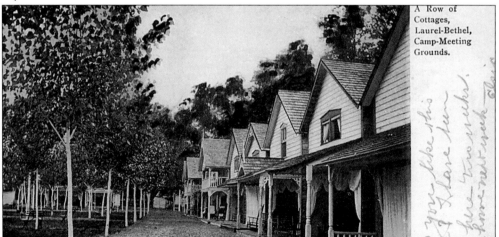

A Row of Cottages, Laurel-Bethel, Camp-Meeting Grounds.

LAUREL-BETHEL CAMPGROUND. This postcard with seven cottages in a straight line with no curve gives you some idea of the size of the promenade. The curtains on each cottage give you an idea of the lack of privacy. Children were not allowed to play in front of the cottages because from the outside edge of the promenade to the tabernacle was considered God's House. There was a pump on both sides of the grounds that provided water for all the cottages. The last religious services were held in 1992.

127

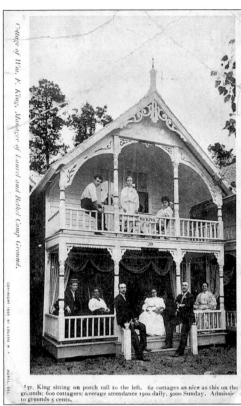

THE COTTAGE OF WILLIAM F. KING. This was the cottage of the camp manager, William F. King, who is seated on the porch rail to the left. The architecture of this cottage was typical of the others. It was number 20 of a total 62. They were built on a promenade circle around the preaching pavilion. Water was pumped from wells scattered around the grounds; toilets were maintained by the camp. The food and confectionery businesses were sold each year and a charge of 5 cents was made for visitors but was not levied on the cottagers who built their own cottages.

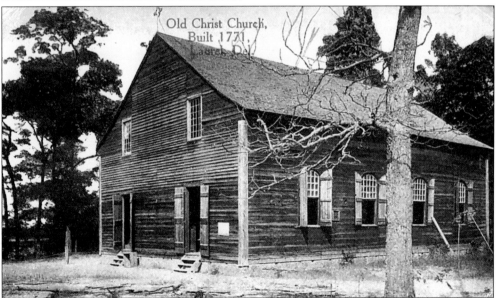

OLD CHRIST CHURCH. This church was founded as a chapel of ease for Stepney Parish in 1771. After the Mason-Dixon Line was drawn, this church was in Delaware. It is located on Chipman's Pond. Bishop Cook, the bishop in 1925, received a speeding ticket on his way to the church. He was clocked at the awful speed of 47 miles per hour. His excuse was that he was late. The church is open July 4th and Sundays April through October from 1 to 4 p.m.